BILSTON, BRADLEY & LADYMOOR
From Old Photographs

RON DAVIES & ROY HAWTHORNE

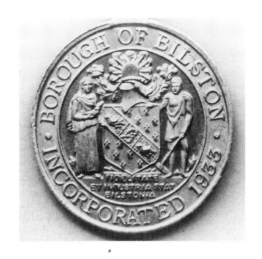

AMBERLEY

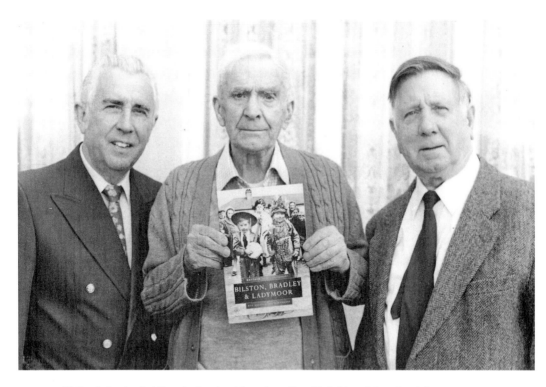

97-year-old Frank Rudge holding the book with authors Roy H (left) and Ron D (right).

This edition first published 2010

Amberley Publishing Plc
Cirencester Road, Chalford,
Stroud, Gloucestershire, GL6 8PE

www.amberley-books.com

British Library Cataloguing in Publication Data.
A catalogue record for this book is available from the British Library.

ISBN 978 1 4456 0165 6

Typesetting and Origination by Fonthill.
Printed in Great Britain.

Contents

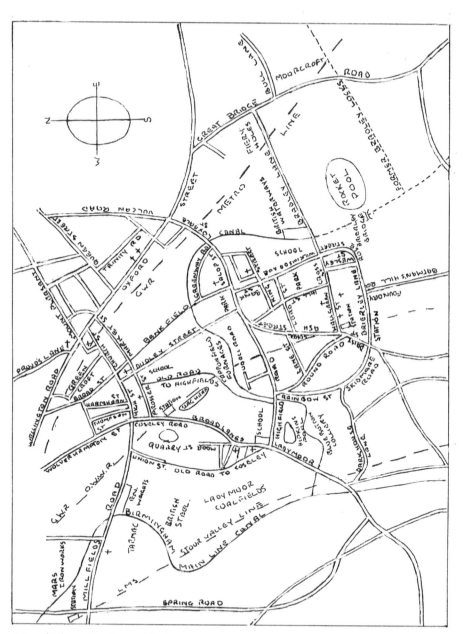

Map of Bilston, Bradley and Ladymoor.

Introduction

Bilston is of considerable antiquity (mentioned in the Saxon foundation charter of AD 994 and the Domesday Charters), but only really developed because of the industrial revolution. Bradley (also mentioned in the Domesday Charters) and Ladymoor-Broadlanes, however, were born as a direct result of this industrial phenomenon, but owing to an industrial decline in the 1920s and a far reaching post-Second World War slum clearance act there is very little that remains of this important phase in our history, and only by old photographs are we now able to identify our past.

Other local views were produced by artists who took the trouble to put pen or pencil to paper. We should be grateful to them, to the ordinary people with simple cameras, and also the professional photographers, all of whom took time off from their precarious living to capture the scenes around them. There appears to have been no shortage of photographers, but artists were thin on the ground to say the least, with just the odd one in Bilston and Bradley – whereas Ladymoor-Broadlanes seemed to attract them, helped a great deal by the enthusiasm of the art staff of the Broadlanes School. One of these pupils was Professor Robert Baker, who became a ceramics expert at Wedgwood and later at Worcester, where his Evesham Ware designs still remain in great demand. Harry Eccleston OBE, who as a boy wandered around the area sketching scenes and anything that caught his eye, was to achieve fame as the first resident artist for the Bank of England, for whom he produced the finest ever banknotes. These ranged from the humble 10s note to the £50 note, all beautiful works of art. The late Andrew Barnett, local historian and prolific artist who just lived to sketch, was Headmaster of Red Hall Junior School, Lower Gornal. All three were Broadlanes School scholars.

Bradley is well known as being the cradle of the Black Country. This is because John Wilkinson, the legendary iron master, came into the area and built what was to be the first blast and mother furnace in about 1768, not 1758 as other historians insist. His legacy in Bradley lasted until about the 1920s; today there is little to show that this seat of smelting iron with coal technology ever existed. The old Lower Bradley north village also ceased to exist at about the same time, while the demise of Upper or Old Bradley, as it is now known, took place during the 1960s. We are lucky that some photographs of Lower Bradley survive, although there is virtually nothing left on the ground.

Bilston took on the role of Big Brother to Bradley, as far as its business interests were concerned. Banks were founded and hotels were created on the now busy stage-coach A41

highway, which ran directly through the town until the new Wellington Road was laid down by Thomas Telford in the 1820s. The main churches were here as were the larger houses for the local gentry.

Many photographs exist of the old and not so old Bilston, but missing are church groups and activities, also street scenes of Oxford Street South, Temple Street, Market Street, Dudley Street, Wolverhampton Street and Broad Street – all busy thoroughfares, and so badly needed to complete the Bilston story.

Ladymoor-Broadlanes was a typical industrial village, a valley hemmed in by canal, railway and tip embankments. It was the main colliery area for the local furnaces and iron works that dominated the valley, such as the Spring Vale Works, Capponfield and the New Coseley furnaces; some photographs and sketches do exist, but certain odd corners of the village would be most welcome additions. This must be done quickly before the passing of the old generation, who were and still are acquainted with the former scenes, and have many tales to offer.

We hope you enjoy the book as much as we have enjoyed compiling it.

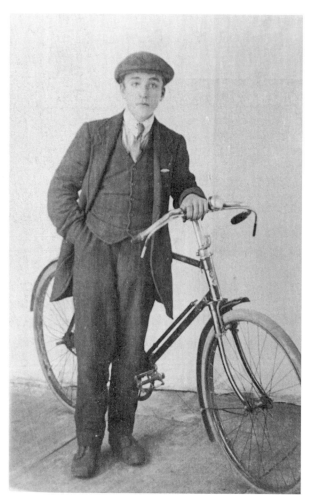

Frank Rudge standing by his brother's bicycle (a Quadrant) at the Bilston photographic studio of P. R. Bartlett, which stood in the corner of Walsall Street and Church Street. The picture was taken in 1917 when Frank was just fourteen years old. He lived in Hilly Road and worked for shoe repairer Tommy Whitehouse in Hall Green Street. They were busy renovating army boots for First World War soldiers. Frank eventually went on to run his own business. (F. Rudge)

one

Bilston

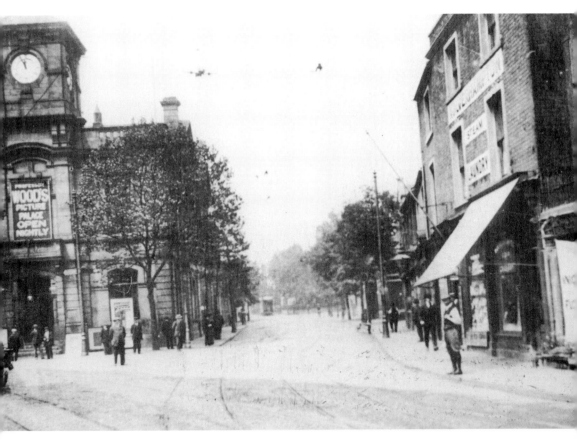

When this picture was taken in 1921 the Grand Electric cinema in Church Street, together with the Town Hall film shows, were about to close because of the new luxurious Wood's Palace cinema opening close by in Lichfield Street. The gentleman wearing the cap, centre left, is Arthur Lyons; he was chauffeur to Mr T. R. Wood, owner of the new cinema. Knight's Florists occupy the shop on the extreme right of the picture, which had previously been a corset maker's. (*A. Lyons*)

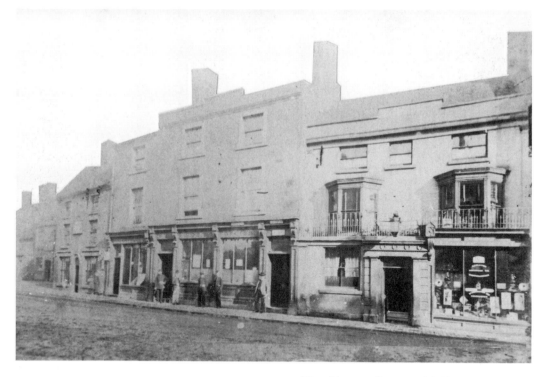

The old post office in Lichfield Street, before 1890. Note the uniformed postmen standing in front. The handsome building on the right was the former Kings Arms Inn, which besides being the principal coaching inn had also served as a court of law. (*Ray Fellows*)

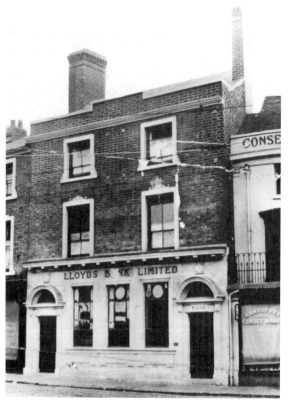

An early view of Lloyds Bank, which took over the old post office premises. Again note the Kings Arms on the right, now the Conservative club. (*Lloyds Bank*)

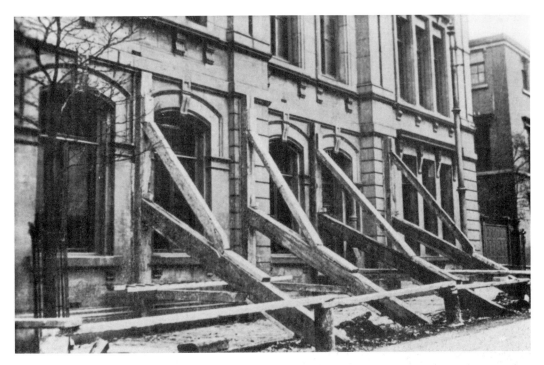

The Town Hall in Lichfield Street, 1906. It is shored up owing to subsidence, caused by mineshafts underneath the foundations. (*John Price*)

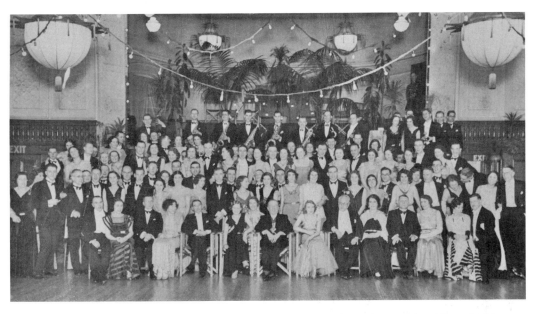

The Mayor's Ball, held in the Town Hall, Lichfield Street, mid-1930s. Now that Bilston had its new Borough status the event flourished even more. Included in this group are: Walter Hughes and his niece Gwen, Mr and Mrs T. R. Wood, Mr and Mrs A. Darby, Herbert Beach, Mr Baker, Mr and Mrs Lofthouse, D. Stone, Jack Bird and Mr Allmark. (*Angela Bird*)

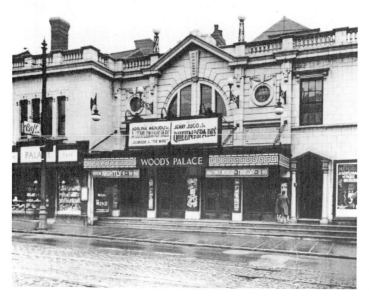

The cinema in the early 1920s. The tramlines, set in granite blocks, are clearly visible in the foreground. Overhead power wires had replaced the old Lorain system which had been used since 1902. On the left is the Palace Café which patrons would visit before or after a film. (*Angela Bird*)

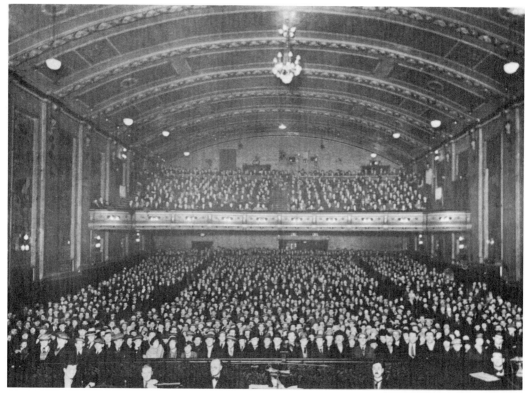

Councillor S. Haddock opened the main entrance door to the new Wood's Palace on Thursday 17 November 1921. The cinema was outstanding for its time, second to none. It held 1,400 and had luxury seating. The orchestra pit accommodated twenty performers. The first film shown was *The Old Nest*. Councillor T. R. Wood introduced his father and his little daughter to the assembly. (*Angela Bird*)

A view from the balcony at Wood's Palace, early 1920s. The architect was Mr Hurley Robinson of Birmingham and the builders awere Messrs Hickin of Willenhall. The decoration was by Val Prince and the beautiful plush purple seats were supplied by Lister's of Bradford. The motor generators for the projection room were supplied by the ECC Works in Wolverhampton. (*Angela Bird*)

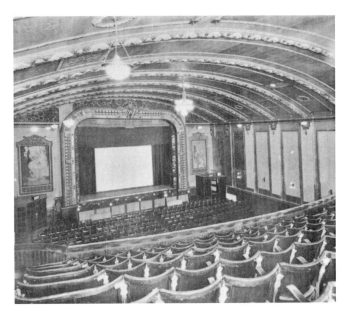

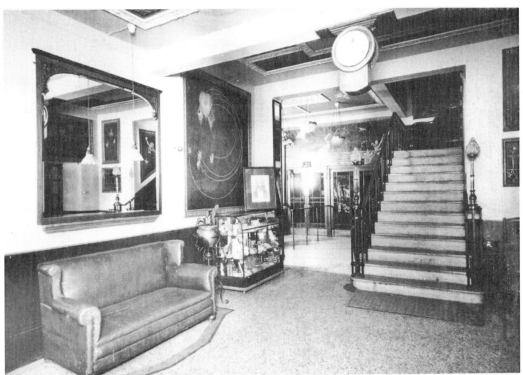

The impressive foyer of Wood's Palace, 1921. The lighting throughout the building was provided and installed by Gimble and Sons of Leicester. The stage could accommodate the largest travelling companies. There were seven dressing rooms with first-class amenities for visiting artists. A press report at the time stated that the magnitude and beauty of the Palace could only be realised on personal inspection. (*Angela Bird*)

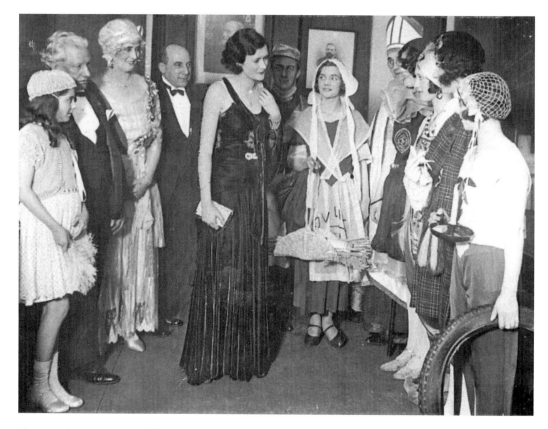

The annual cinema ball and fancy dress held at the Town Hall, 1931. It was organised by Councillor and Mrs T. R. Wood in aid of the Nursing Association and the Children's Holiday Camp Fund. Left to right: Miss A. Wood, Councillor T. R. and Mrs Wood, Mr C. Soloman, Molly Lamont, the film star, centre – judging the contestants. Winners included Mrs M. Haddock, Miss Jean Tonks and Miss Marie Bussey. (*Angela Bird*)

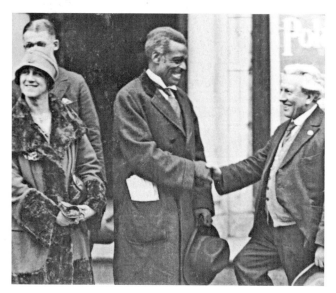

On Friday 9 March 1928 James B. Lowe, the America film star, paid a visit to Wood's Palace. He is pictured shaking hands with Councillor T. R. Wood, managing director of Wood's picture halls. On the left is Mrs Wood and behind is Mr E. Wigley, manager of the Palace. Mr Lowe was the star of the new film *Uncle Tom's Cabin*. Over 100 people gathered outside the building as James Lowe read extracts from one of the children's books on which the film was based. The cinema was to show the film later in the year. (*Angela Bird*)

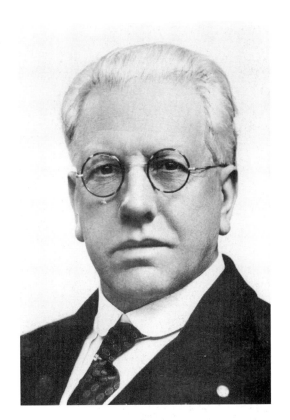

Mr and Mrs T. R. Wood in 1935, when they
were to become Mayor and Mayoress of
Bilston. (*Angela Bird*)

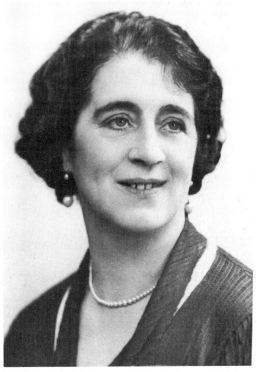

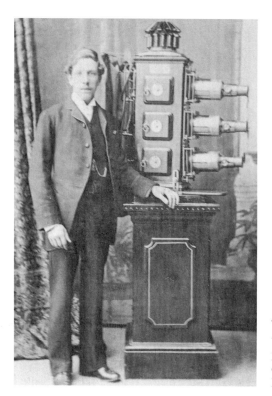

Thomas Wood as a nineteen-year-old with his three turret lens magic lantern, 1887. It was powered by acetylene gas, which was directed on to lime blocks to produce a high-intensity light source for the glass plates. (*Angela Bird*)

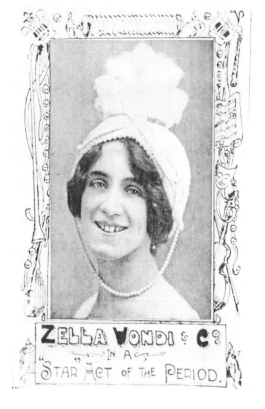

Zella Vondi was the stage name of this lady. She was also the Mayoress of Bilston during 1935-6. After gaining her ALCM at the young age of sixteen, she first became a concert pianist appearing both in London and the provinces. Later she went on to the music hall and variety theatre, appearing with George Robey, Harry Lauder and Vesta Tilley. (*Angela Bird*)

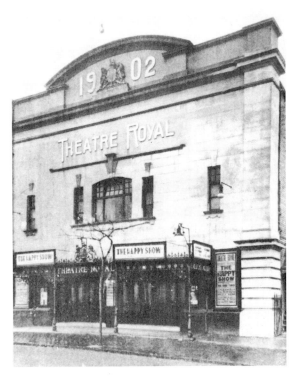

The Theatre Royal, Mount Pleasant, Bilston, advertising 'The Happy Show', c. 1930. The theatre was also used for film shows during the First World War. Variety, revue, drama and circus all featured. When elephants refused to walk on stage, sensing it was unsafe to carry their huge weight, the message eventually got through to the staff, and support props were erected underneath the floor before the animals trooped on without further ado. (*Angela Bird*)

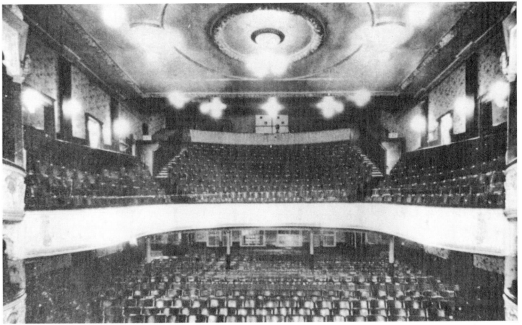

An interior view of the Theatre Royal from the stage, 1930s. It was opened in 1902 and demolished in 1961 after it had been purchased by the local authority. Such stars as Bruce Forsyth and Max Bygraves appeared there in their younger days. (*Angela Bird*)

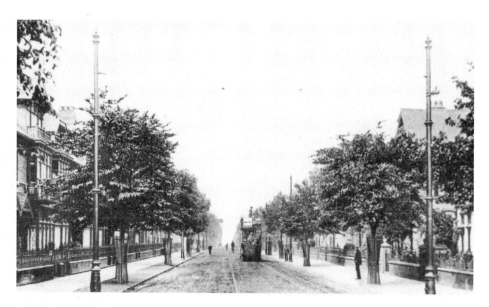

An early view of the Wellington Road looking towards Wolverhampton, with the tram heading for Bilston Town, *c.* 1910. Note the fencing protecting the trees. (*R. Fellows*)

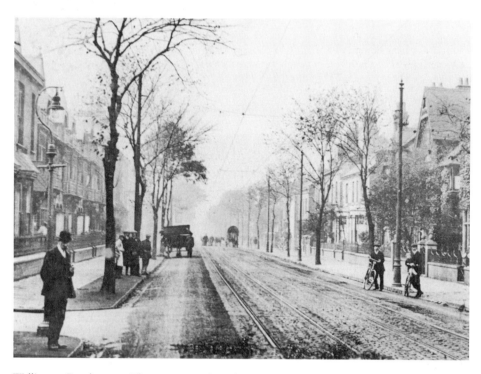

Wellington Road, 1920s. The trees were planted in 1873 on the instigation of two former Bilston historians, George Lawley and John Freeman. The bicycles look fairly modern, and there is a lovely lack of motor vehicles, the road being dominated by horse-drawn carts, which gave rise to the saying 'keep out of the horse (hoss) road'. In the distance a man appears to be herding cattle. (*John Price*)

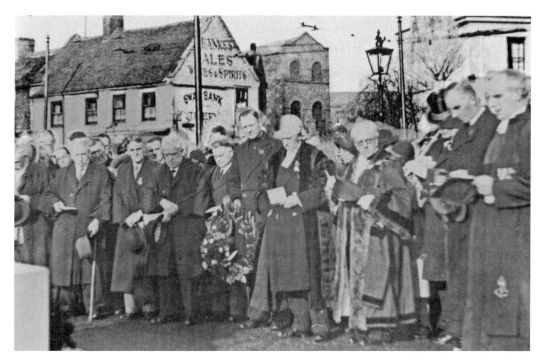

Remembrance Service in Oxford Street, 1936. The Major, T. R. Wood, can be seen with a group of dignitaries, including the Revd Mr Goodwill, the Wesleyan minister, and the Revd Havelock Davison from St Leonard's Church. The Swan Bank Tavern is in the background. (*Angela Bird*)

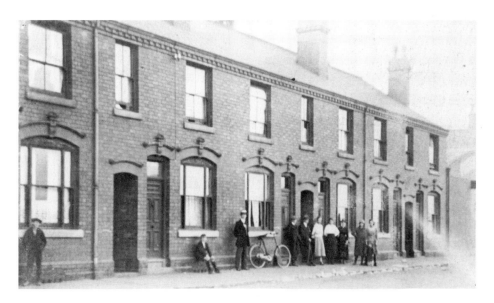

Queen Street, 1931. Mr G. Green is standing by his bicycle and wearing a straw hat. He lived here with his wife, the lady dressed in white. The group of relations and neighbours appears to be watching a procession pass by. On the extreme right and just visible is the Queen Street Motor Garage Co. Ltd. (*R. Fellows*)

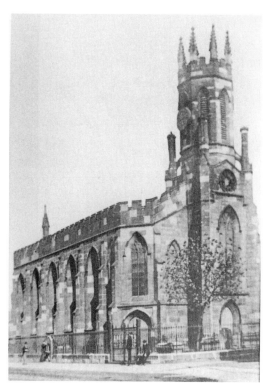

An Edwardian view of St Mary's Church in Oxford Street. On the extreme left of the picture someone is drinking from a fountain, and someone else is waiting. There were three such fountains in the town; another was located outside the Primitive Methodist church in High Street. (*John Price*)

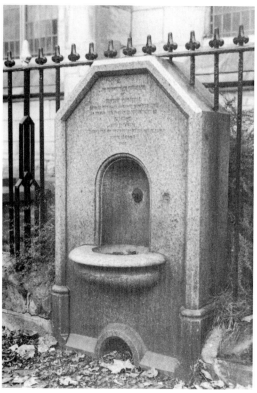

The drinking fountain outside St Mary's as it remains today. (*Roy Hawthorne*)

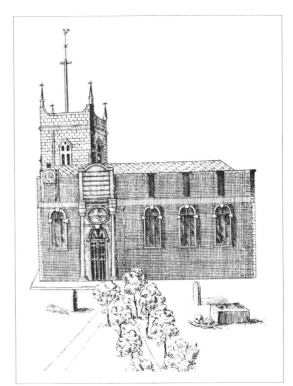

A sketch of the early St Leonard's church, Walsall Street, as it was before the present church was built in 1826. It is said that parts of the old tower were retained in the present tower. (*John Price*)

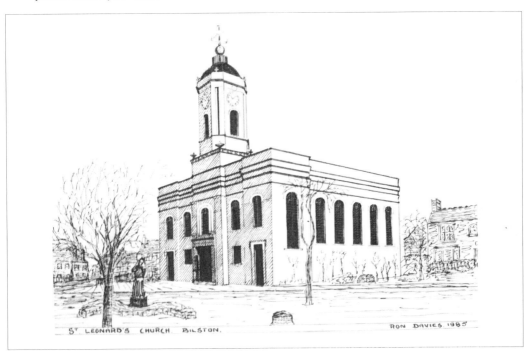

ST LEONARD'S CHURCH BILSTON.

RON DAVIES 1985

This sketch of St Leonard's church shows it to be the fairest church in the so-called Black Country. It was built in 1826 in the Classical style to a design by Francis Goodwin. (*Ron Davies*)

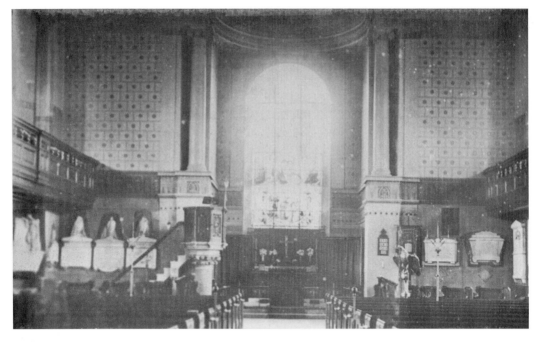

An early interior view of St Leonard's church, *c.* 1915. (*John Price*)

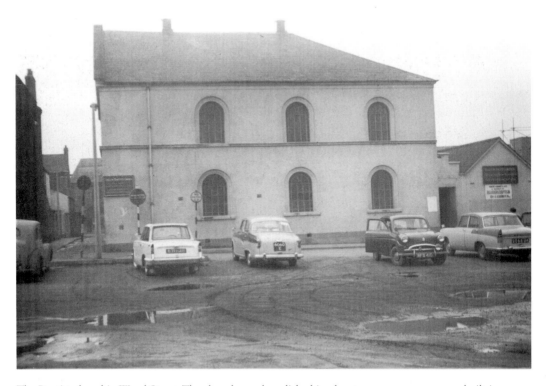

The Baptist chapel in Wood Street. The chapel was demolished in about 1972; a new one was built in Proud's Lane. (*H. Eccleston*)

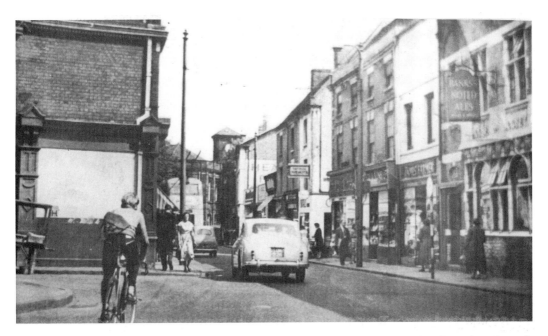

Looking towards the Town Hall, *c.* 1950. The building on the left was the Board or the Hole in the Wall, as it was popularly called; Len Willis' fish cart is outside. The pub on the right is the Horse and Jockey, next to which was James Farmer's gents' outfitters; next came Preedy's tobacconists and Wooldridge's bread shop. (*A. Barnett*)

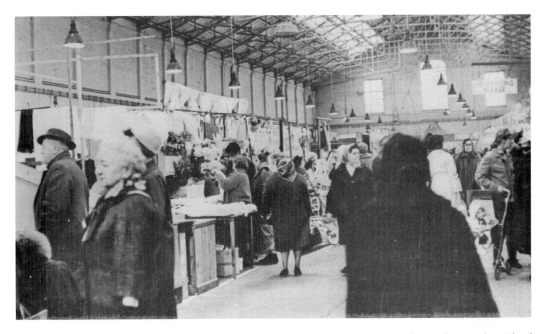

Inside the old Bilston Market, 1960s. The lady nearest on the left is Mrs Adams. She was the wife of Joseph Adams, who was the popular pigeon-flying publican of the Old Bush public house in Skidmore Road, Daisy Bank. (*M. Tilley*)

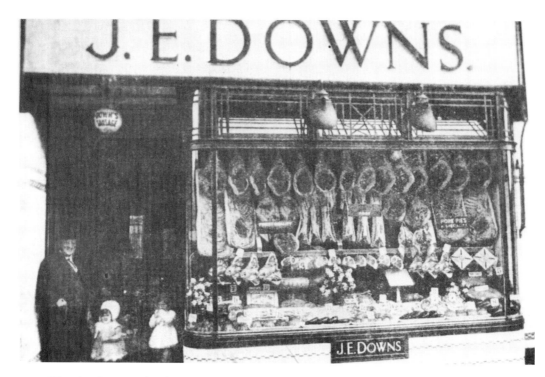

When butchers were butchers, *c.* 1930. Note the hams and sides of bacon. Were these the good old days? It seems so. Joe Downs was also noted for his pork pies; in later days his vans were pork-pie shaped. The light globe over the doorway advertises Down's Sausages. These were actually made in the shop, and were a great attraction for the huge influx of customers. (*Ron Davies collection*)

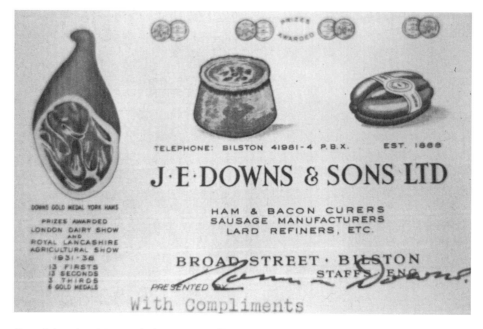

One of the advertising cards that Downs offered to his customers. (*Ron Davies collection*)

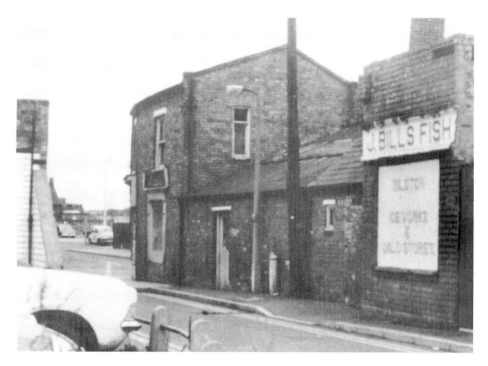

For many years J. Bill's fish and poultry shop held sway in the town, its fish the very best and with a variety one never hears of today. It was reduced to producing ice and selling potatoes when this photograph was taken in about 1970; it was a sign of the decline of most of the popular shops that once filled the town. (*Ron Davies*)

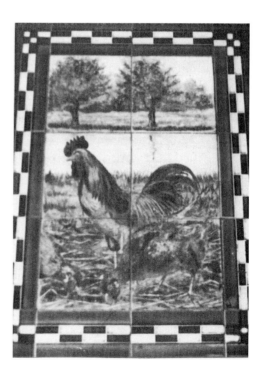

Bill's shop had well-tiled walls, including ornamented tiles advertising the monger's trade of fish and poultry, such as the one seen here. (*Ron Davies*)

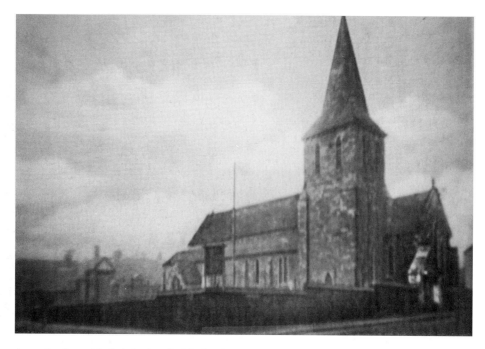

An early view of St Luke's church, Market Street, c. 1920. St Luke's School is seen to the left of the picture. This is a John Price postcard. (*John Price*)

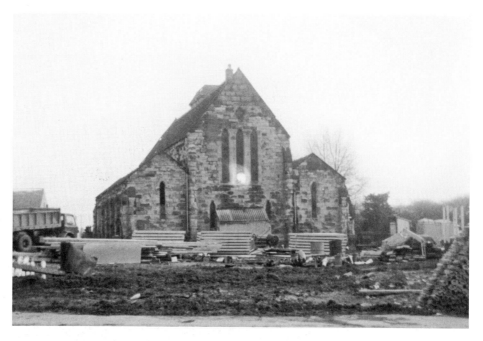

A new view of St Luke's church from Dudley Street, c. 1975. The slum clearance bit deeply here: seemingly overnight St Luke's School, Dudley Street and the church vanished without a trace, along with the old Market Hall just visible to the left of the church. (*Ron Davies*)

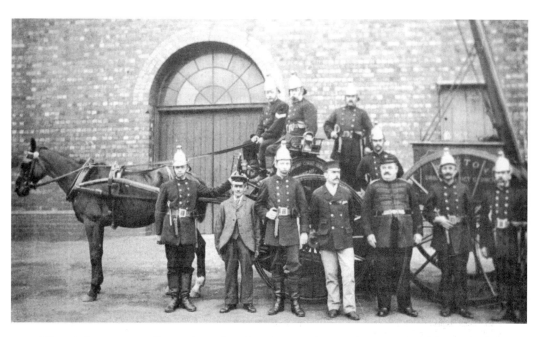

Bilston's firemen were all part time when this photograph was taken in 1894. Their call to duty was signalled by the ringing of a bell situated in Market Street. Horses continued in service for a further thirty years until the motor fire engine replaced them in 1925. (*John Price*)

The old fire station, *c.* 1968. The outdoor market lay to the right of the picture and a row of old houses stood where the cars are parked. (*R. Arnold*)

Prosser Street before the civil engineers moved in, 1985. On the right is the boundary fence to Charlie Purslow's pigeon pen; on the left is the old fence containing Doughty's Bucket and Light Metal Fabrication Works, while adjoining this is the little Zionist chapel. The other buildings are council properties, with Sankey's offices in the distance dominating the whole. (*Ron Davies*)

Sankey's main Albert Street offices during demolition, 1995. (*Ron Davies*)

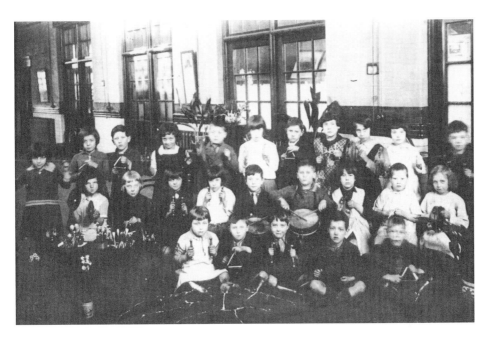

Stonefield Infant School, *c.* 1932. Back row, left to right: -?-, Howard Lowe, Vera Evans, -?-, Olive Walters, Leonard Hill, -?-, -?-, -?-, -?-. Middle row: Mavis Phillips, -?-, Lilian Cotterai, -?-, Joan Walters, Doug Meese, George Langford, -?-, Louise Goddard, -?-. Front row: -?-, -?-, Ron Davies, Barry Davis, -?-. (*D. Meese*)

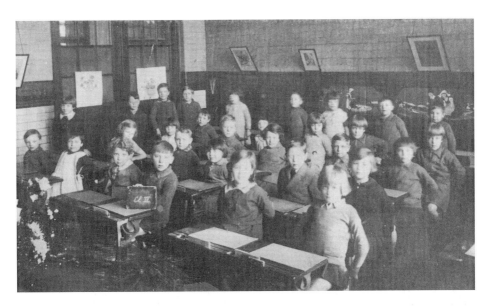

Another class at Stonefield Infant School, *c.* 1932. Back row, left to right: ? Shelton, -?-, -?-, -?-, Sid Stanley, Dennis Leek. Fourth row: Harry Sirret (standing), -?-, -?-, Kath Davies, the Baker twins. Third row: John Pope (standing), Dora Beasley, Albert Hill, Kath Anthony, Stan Probert, -?-. Second row: -?-(standing), Eileen ?, Tommy Edwards, Mary Turner, Arthur Boswell, -?-. Front row: Tommy France, -?-, Billy Tilt, Ron Arnold, Joan Gibbs, Lily Lloyd. (*R. Arnold*)

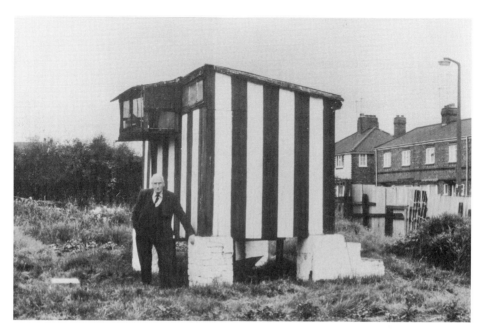

Charlie Purslow's pigeon pen, or the Stonefield Lofts as they were facetiously known. They stood in Prosser Street from at least the 1930s until their removal in 1998 to the Black Country Living Museum. The council houses on the right gave way to the new Black Country Route in about 1994. (*Ron Davies*)

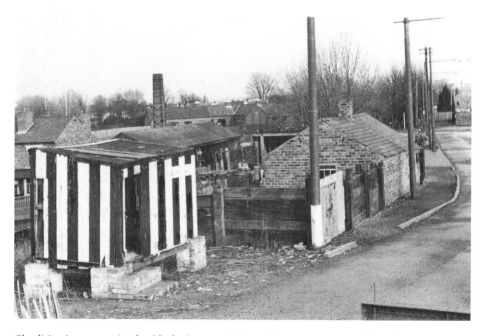

Charlie's pigeon pen in the Black Country Living Museum, 1999. To the right are the little buildings of the former Hickman Hardware in Millfields Road, which includes the Bilston stone building. (*Roy Hawthorne*)

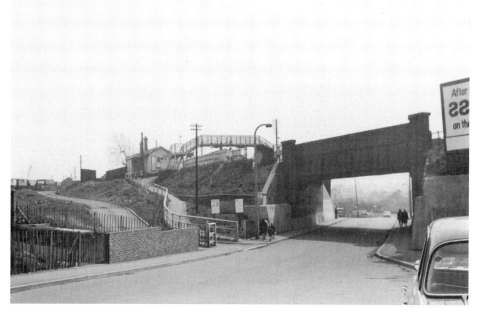

A picturesque view of Coseley Road station, or GWR West, on the Oxford, Worcester and Wolverhampton line, or the Old Worse and Worse Railway, as it was nicknamed. (*H. Eccleston*)

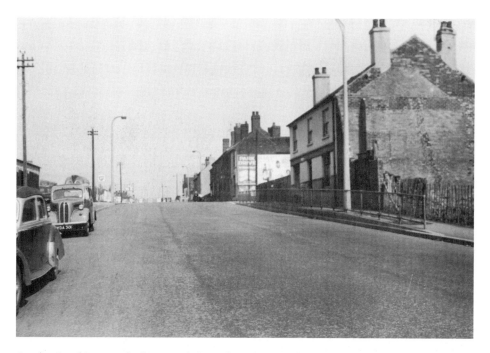

Coseley Road in 1970 looking north from the railway bridge, showing the Union public house, the nearby houses now gone; the other buildings higher up were soon to follow suit. The building on the corner of Prosser Street with the hoardings was Blewitt's general groceries, formerly Stone's groceries. (*H. Eccleston*)

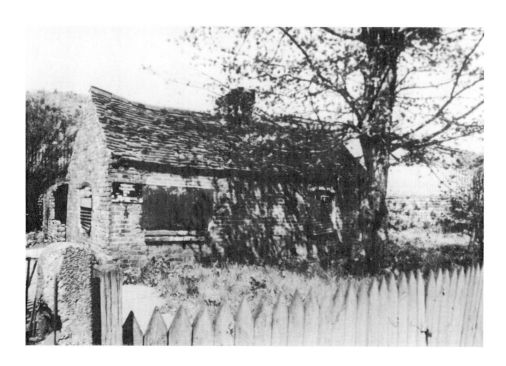

This little cottage stood at the lower end of Coseley Road. The Pitt family lived here for many years, giving rise to its name, Pitt's Cot. It was abandoned for a number of years and, becoming ruinous, was rescued in the nick of time and is now a main feature at the Black Country Living Museum. (*Ron Davies*)

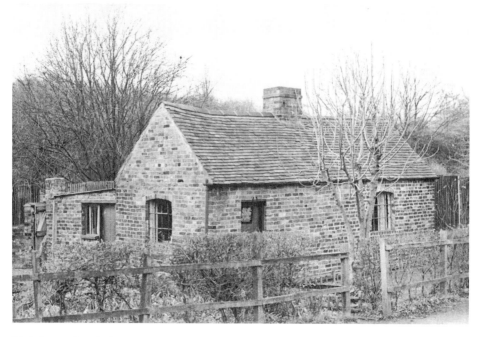

Pitt's Cot at the Black Country Living Museum, 1999. (*Roy Hawthorne*)

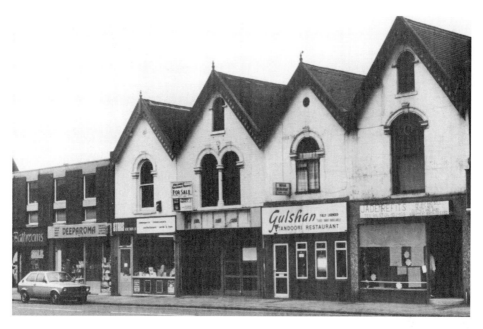

The attractive buildings here are in High Street, c. 1982. They are an architectural mixture of gothic barge-boarded gables and classical upper windows. The third building from the right was for many years the Alhambra Cinema; fourth from the right was Taylor's sweets, ice cream and newsagent's, which is still a newsagent's. The newer buildings on the left stand on the site of the Bull's Head public house, which was demolished in about 1975. (*Ron Davies*)

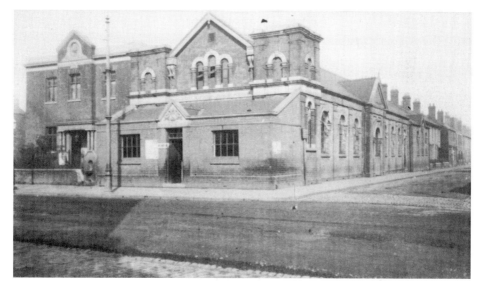

The Primitive Methodist church in High Street. The large building that extends well into Thompson Street was actually the Methodist school, with the main church being the building on the extreme left. Another fountain given by John Mason is to the left of the school building. The whole was demolished during the latter days of 1962. The cobblestones in the foreground were at the entrance to Quarry Street, also gone now. (*A. Barnett*)

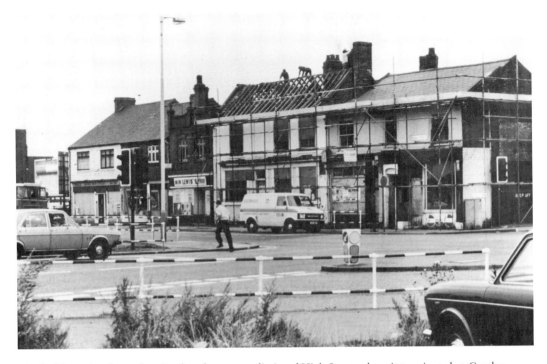

The buildings that formerly existed at the western limits of High Street where it terminated at Coseley Road, *c.* 1985. The end building was Fones or Jones, who were painters and decorators, etc.; it later became Stallard's motor-cycle shop. The shop adjacent was latterly that of one Chaman Lal, but for many years previously it had been Hislop's cake and bread shop. The building with the men working on the open roof was the Bird in Hand public house; next came Lewis' School of Motoring. This building was a little gem architecturally, and had also previously been a cake shop, run by the Barker family who also ran the remaining buildings as ladies' and gents' hairdressers. (*Ron Davies*)

This scene, photographed in 1987 or 1988, is a sight to strike disbelief into all pub lovers in the town. It shows the demolition of not one but two popular public houses in Wolverhampton Street: the nearest was the Hand and Keys, and the building beyond with the skeletal roof was the Barrel. In between them stood, among some houses, the Hand and Bottle, and beyond the Barrel was the Old Bush. (*Ron Davies*)

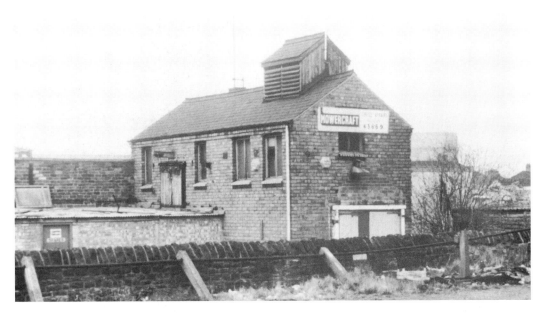

This building stood more or less at the corner of Wolverhampton Street and Millfields Road; it was formerly Young's the butcher's slaughterhouse, and was later used as a lawnmower repair and service business. The wall was built of Bilston stone, and its triangular capping stones were known as donkeys' heads; all of this has now disappeared. Note the Bilston Gas Works' gasometer in the background. (*Ron Davies*)

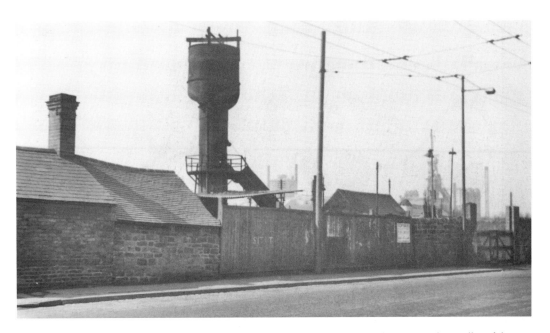

The Millfields Road cupola, with the Elisabeth furnace in the background, *c.* 1955. The smaller of the two buildings was the last stone building in Bilston; it is now a feature, along with its adjacent building, in the Black Country Living Museum. The cupola belonging to Bradley & Foster's produced pig-iron, and was not used for founding cast-iron goods. It was known as the Pop Bottle. (*H. Eccleston*)

A canal scene near Bilston Street canal bridge, Wolverhampton, 1980. Although strictly beyond the scope of this book, it shows that the wharf here was created out of Bilston stone grindstones. A similar scene exists today at the Black Country Living Museum. (*Ron Davies*)

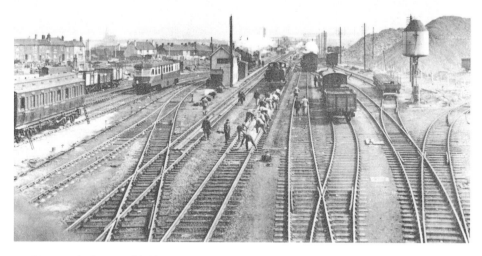

Looking south from Millfields railway bridge towards Coseley Road railway station, 1958. Platelayers are busy on the main line, with the scene looking more like the busy junction at Crewe. The track branching off to the right took mainly iron ore into the steel works to feed the Elisabeth furnace. The houses to the left were in Coseley Road. Note the hazy form of St Martin's church, Bradley, in the distance, and also the form and stacks of Perry's foundry on the right in the background. The mounds seen on the far right are slag, dumped by Tarmac Ltd and awaiting further use. (*M. Hale*)

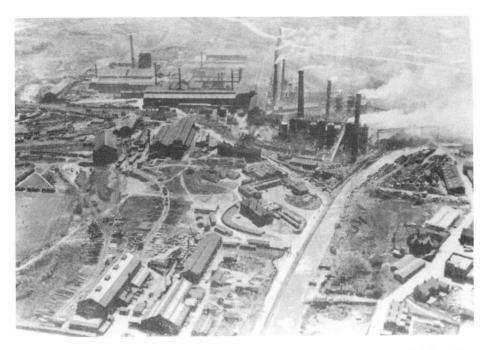

An aerial scene of the steel works, 1940s. E. N. Wright's foundry is in the foreground, followed by the steel works offices, the canteen, swimming baths and then the old blast furnaces; the Siemens steel melting shops are situated just to the left of the furnaces. (*John Price*)

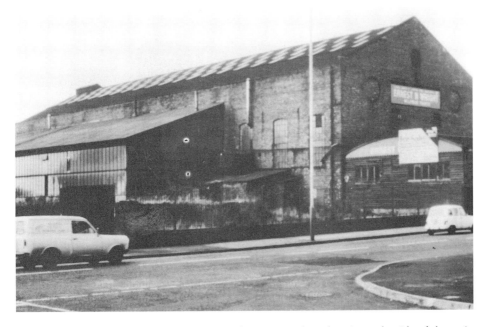

E. N. Wright's constructional shop, *c.* 1985. The new template shop is on the side of the main building, while the old template shop with the Belfast roof is on the near end of the building. (*Ron Davies*)

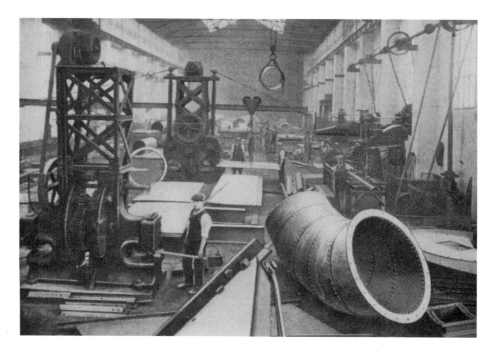

Inside the constructional shop at E. N. Wright's, *c.* 1933. The scene includes two belt-driven machines capable of shearing steel plate, punching holes and chopping angle iron, and radial drillers on the right of the picture. In the foreground is a bent section of riveted pipe work, although some electric welding was carried on at this time. The man standing by the first machine is Jim Perks: he was also a chargehand. (*E. N. Wright Co. Ltd*)

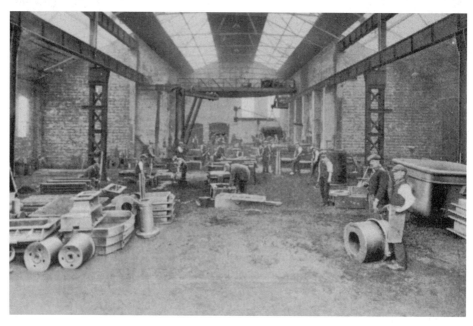

E. N. Wright's foundry, *c.* 1933. (*E. N. Wright Co. Ltd*)

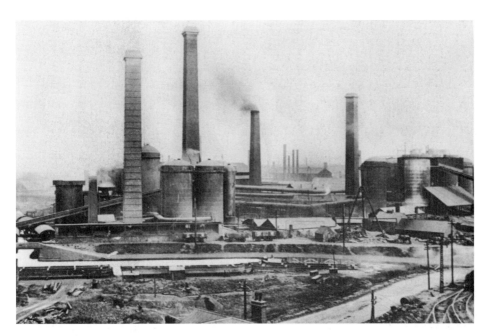

The Spring Vale furnaces, early 1900s. (*John Price*)

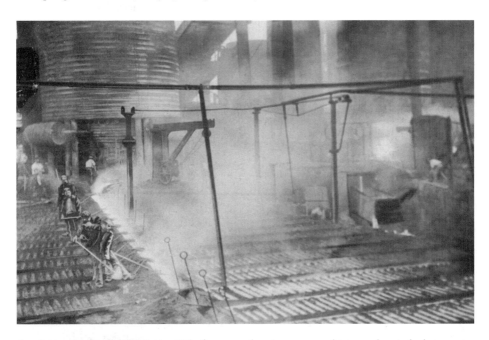

Another early view of the Spring Vale furnaces, showing men working on the pig-beds, *c.* 1900. Here molten iron is seen running from the blast furnace down what is called a runner, which leads to side channels called sows, from which the iron runs into shorter channels called pigs. This process is supposed to represent a sow being suckled. On cooling (not cold) the pigs, weighing about 1 cwt, are easily broken away from the sows with sledge hammers; the beds are sand based. Pigs are now mostly made by casting them in a machine and only weigh ½ cwt. (*John Price*)

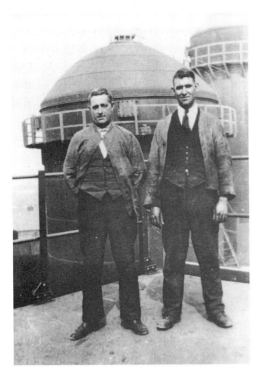

Two blast-furnace keepers posing on top of one of the older furnaces. Note the two cowper stoves in the background: they created hot air that fed into the furnace. The person on the left is Tom France of Ladymoor; the other is Ernie Barwell, who came from the Sedgley Gornal area. (*Dorothy Davies*)

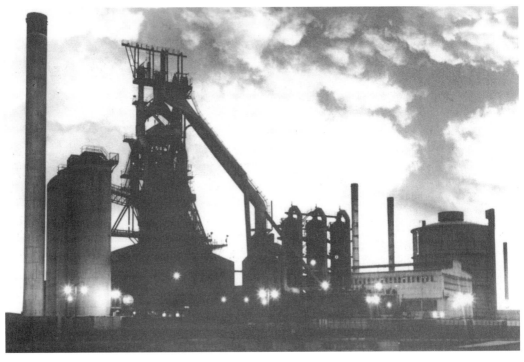

Bilston Steel Works, 1966. The Spring Vale furnaces were purchased by Alfred Hickman 100 years earlier in 1866. It operated as an iron works until 1884, and was then converted to steelmaking. In 1920 the works came under the wing of Stewarts and Lloyds. On nationalisation the works became known as British Steel, until their closure in 1979. (*Roy Hawthorne*)

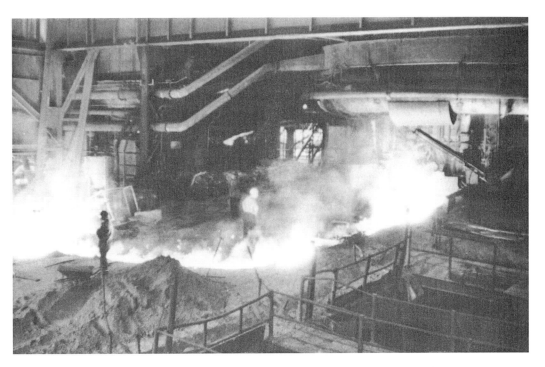

The Elisabeth furnace being tapped, either for its slag or its iron, *c.* 1970. (*H. Eccleston*)

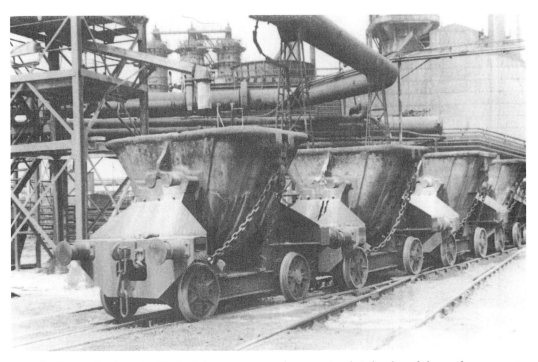

Ladles moving into the Elisabeth furnace area ready to receive their burden of slag or furnace waste, *c.* 1970. (*H. Eccleston*)

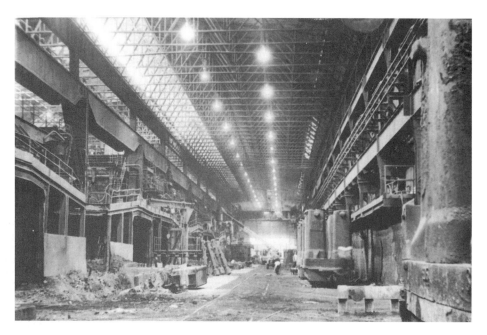

A long view into the Siemens or melting department, c. 1970. Note the ingot containers to the right of the picture; they received the newly-formed steel from the furnaces on the landing above. (*H. Eccleston*)

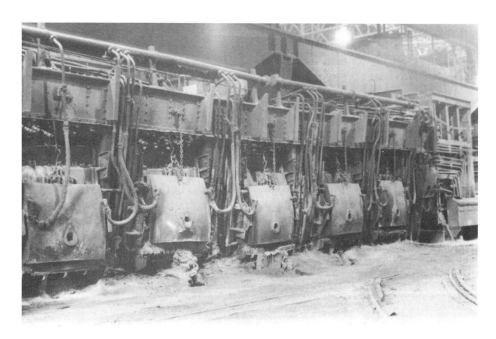

The open-hearth furnaces where raw iron and scrap were converted to steel, c. 1970. The furnaces were concealed behind the water-cooled doors seen here. (*H. Eccleston*)

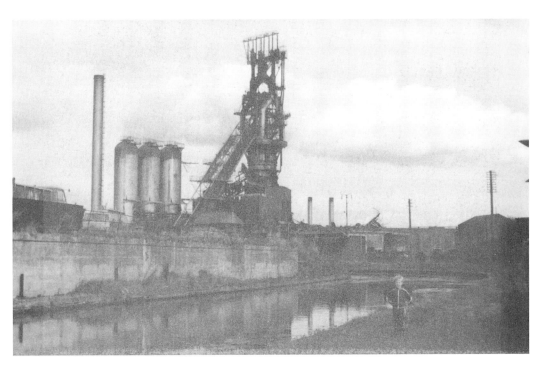

A splendid canalside view of the Elisabeth furnace from the south-west, 1980. She is now solitary and forlorn, the rest having been demolished in 1980, awaiting the explosion that will bring her crashing down. They said she was too expensive to keep as a focal point. (*H. Eccleston*)

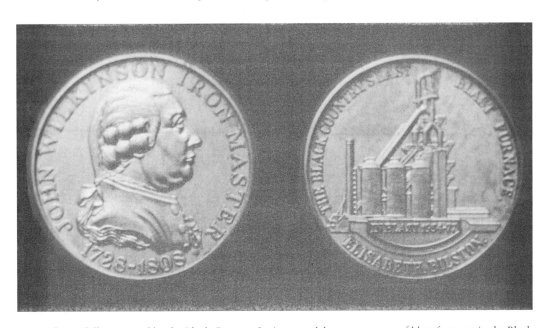

The medallion minted by the Black Country Society to celebrate 210 years of blast furnaces in the Black Country. John Wilkinson erected the first furnace at Bradley in about 1768. The last furnace, at Spring Vale (the Elisabeth), produced its last cast in 1977. (*Ron Davies*)

A Tarmac advertisement from the 1930s.
(*Tarmac Ltd*)

Ettingshall railway station on the Stour Valley Line, or the LMS, *c.* 1960; the shot was taken from
Catchem's Corner. This was a popular station for the workmen who came from the Oakengates district
of Shropshire to work in the local industries here. The station no longer exists, nor does the Union Mill,
on the left, which was taken down in recent years. (*H. Eccleston*)

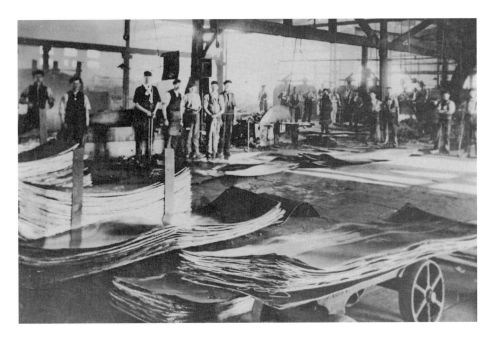

The Mars Iron Works at Ettingshall were situated between Frost Street and Catchem's Corner canal bridge. The works were erected in about 1865 by George Adams and were run by that family until closure in 1920. This photograph of 1906 shows the workmen posing by the newly formed steel sheets. The crude bogie in the foreground was used to transport the steel sheets around the works. (*John Price*)

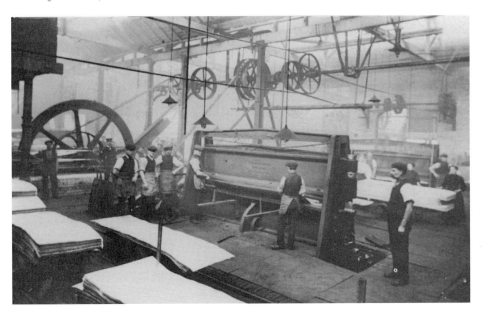

Still in the Mars Iron Works, this scene shows two shearing machines. Note the three women in between the two machines: no safety cages or the like at this time. The rolls lie to the left of the picture. Besides steel sheets, galvanised hoops and bars were also manufactured here. (*John Price*)

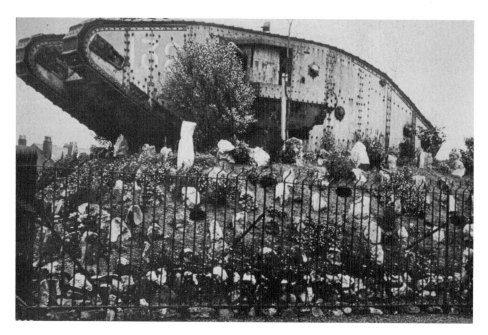

This First World War tank stood in Hickman Park along with a cannon. They were a great attraction for children who loved clambering over them. Then there was talk of another war, resulting in their quick dispatch to help the war effort – a sad loss for Bilston, which seemed to delight in losing its treasures. (*T. Genge*)

A carnival scene in Hickman Park, 1968. The lady on the left is Mrs Beatrice Newall. (*A. Wootton*)

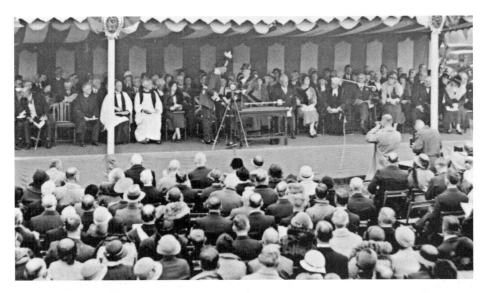

Much publicity was given to Bilston's Charter Day on 28 September 1933, when the Earl of Harrowby presented the official document to the Mayor in front of a huge crowd at Hickman Park. (*Angela Bird*)

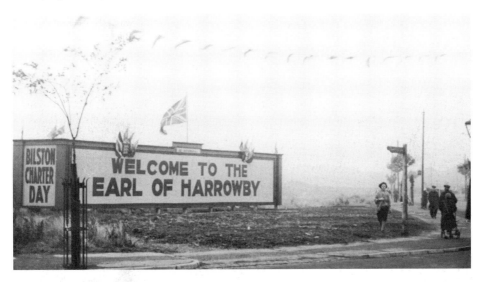

Before Bilston's Charter Day, huge poster boards were erected at various approaches to the town to welcome the Earl of Harrowby; bunting and union flags were also the norm for this important day in Bilston's history. The location appears to be the corner of Proud's Lane and Wellington Road. Bilston's Charter Day was perhaps the most important event in the town's history. On this day, 28 September 1933, the town became a Borough or Municipal Corporation with mayoral status. Councillor Herbert Beach was to become the town's first Mayor.

These were days of depression but Bilston fared just a little better than most areas, and Charter Day was an excuse to celebrate and adorn the streets with flags and bunting. Awards were given for the best-decorated streets, with the most attractive streets receiving plaques that were fixed on some prominent wall of a house and read: 'BILSTON CHARTER DAY 1933 STREET DECORATIONS FIRST AWARD'. (*Angela Bird*)

Councillor T. R. Wood and Geoffrey Mander at Bilston Flower Show in Hickman Park, mid-1930s. The park covered an area of 12½ acres and was opened in 1911. The land was donated by the Hickman family after Sir Alfred Hickman's death in 1910. (*Angela Bird*)

The Crescent from Broad Street, possibly in the early 1930s. What appear to be good well-built properties have now all gone. The overgrown land to the left of the picture is now the site of the unemployment exchange, itself now closed and boarded up. (*John Price*)

The former Jordan Enamel Works in Cambridge Street. It is one of the few old industrial buildings that remain in the town. (*Ron Davies*)

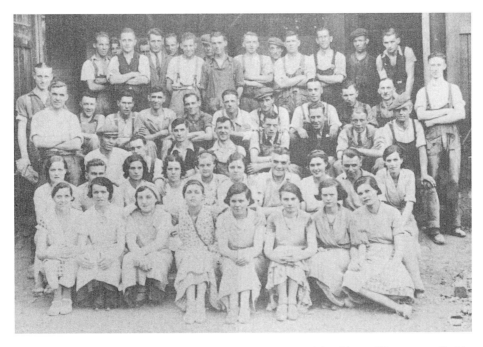

The staff of Jordan's Enamel Works, Earl Street, *c.* 1940. Some of the older staff here were still able, though unofficially, to produce japanned ware as late as the 1950s. In the second row, sixth from left, is Bett Lavender, in the third row, fourth from left, is Les Lavender, while second from left on the back row is Jack Doughty, his wife is eighth from the left on the second row. (*A. Wootton*)

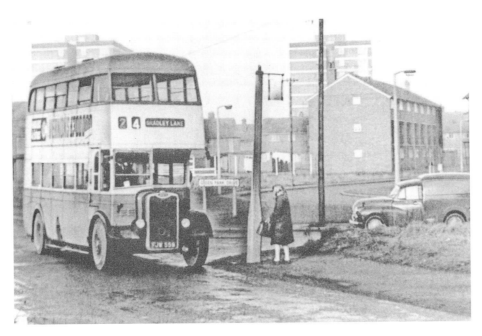

The Bradley Lane No. 24 bus passing Green Park Drive, Stowlawn, 1969. Guy Motor buses were some of the last exposed radiator double-deckers, and they also had open rear platforms. It was at this time that Wolverhampton Transport was taken over by the West Midlands Passenger Transport Executive; it also spelt the end of the once familiar Wolverhampton coat of arms that proudly adorned the buses. (*Wolverhampton Express & Star*)

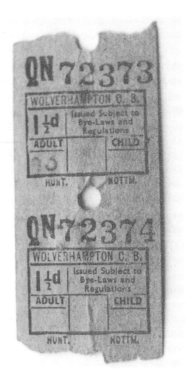

A bus ticket issued by Wolverhampton Transport in about 1965. This particular ticket was issued from Bradley to Bilston and cost the enormous sum of 1½d. (*K. Cooper*)

two

Bradley

The Bradley Bridge referred to in this old advertisement is probably the Pot House Bridge, as the Hatton Works were close by in Greenway Road. (*Samuel Griffiths*)

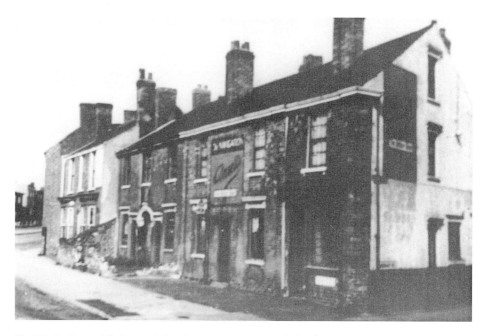

The Navigation public house, Salop Street, *c*. 1970. Beyond the sloping wall is the Star and Garter, while the tall building on the opposite side of the road is the more modern White Hart. (*Jack Smith*)

CLOSED c1959

Salop Street Primitive Methodist Chapel stood at the western end of the street and on its north side. It was an active church until the slum clearance in the late 1950s; the chapel closed in about 1959. Its oldest records date from 1846. (*Ron Davies*)

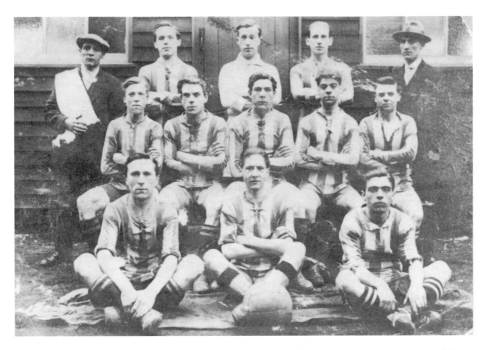

Bradley Prims Football Club, 1922. The only recognisable faces here are top row, second from the left, Sam Durnall and middle row, far left, Thomas Stokes. (*J. Brown*)

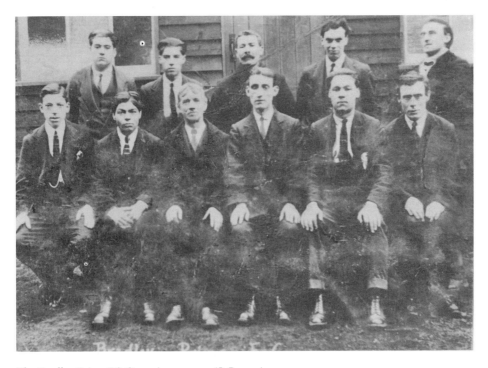

The Bradley Prims FC Committee, 1922. (*J. Brown*)

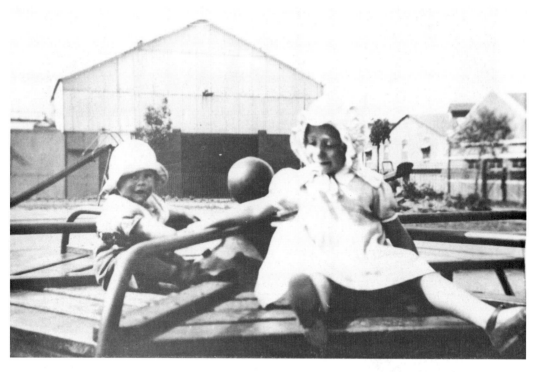

Most local children loved to go to Greenway's playing fields in Bradley during its heyday in the 1930s and '40s. Seen here in about 1940 are little Mary Fownes and her younger cousin Ron enjoying the roundabout ride, on what appears to be a hot summer's day. (*R. Fellows*)

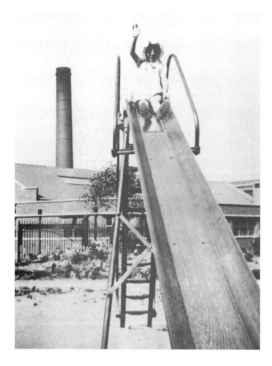

Another snapshot of young Mary Fownes enjoying the big slide. Other attractions were a marvellous sandpit and a water fountain to drink from. (*R. Fellows*)

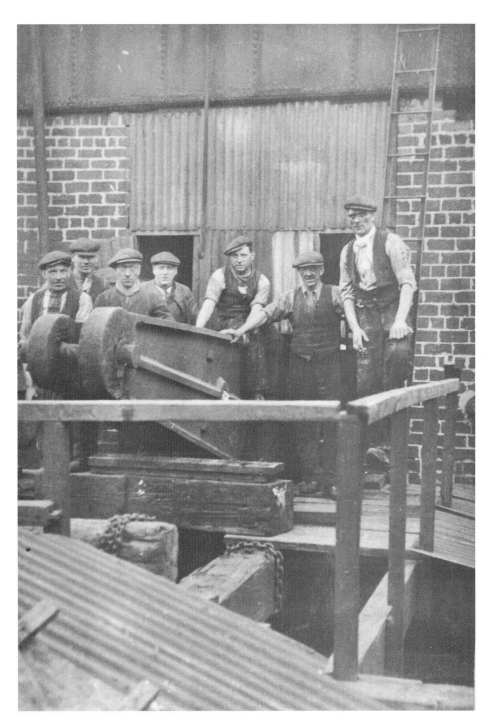

A group of hard-working Black Country lads taking a break at the Caledonian Iron Works in Hatton Street, 1927. Most of them have mufflers and cloth caps, with only one wearing overalls. Third from the left is Thomas Gough and fourth from the left is his brother Harold. They seem proud to be photographed in the company of an ancient cast arm from a beam engine. (*Arthur Gough*)

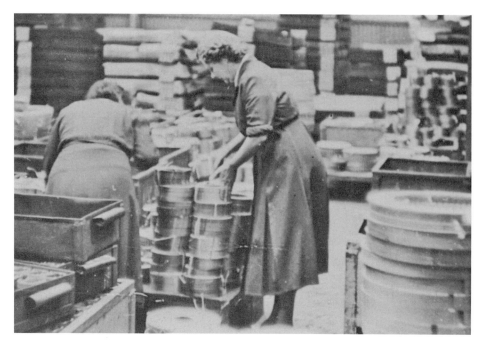

Mrs Jeffries, right, and Mrs M. Fownes at Sankey's Bank Field Works, late 1950s. (*R. Fellows*)

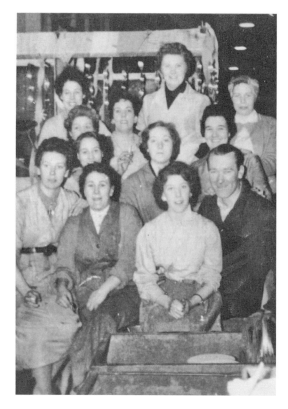

Another group of Sankey's workforce showing June Bowater, third from left on the front row sitting next to Jack Richards. Other friends of June named in the group are Betty White, Pat Mayhew and Becky Perks. The year was 1958 and Miss Bowater was leaving the company to get married. (*J. Stewart*)

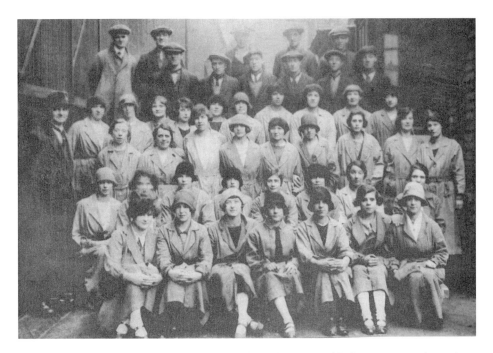

A group of workers at the Bank Field Works. The only recognisable faces are second row from the back, second from the left, Mr B. Cole, and third row from the back, eighth from the left, Phoebe Jenkins. (*Nancy Cole*)

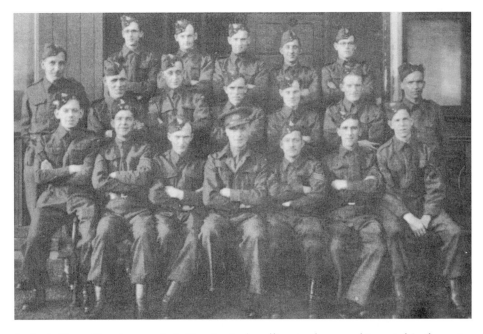

Sankey's Home Guard, 1941. Jack Timmins is the officer in charge and is seated in the centre of the front row. Harry Shepherd is second from left on the back row. Other members included in the group are J. Leadbeater, B. Beasley, G. Willis, H. Nicholls, G. Bayliss, W. Gilbert and A. Fortham. (*H. Shepherd*)

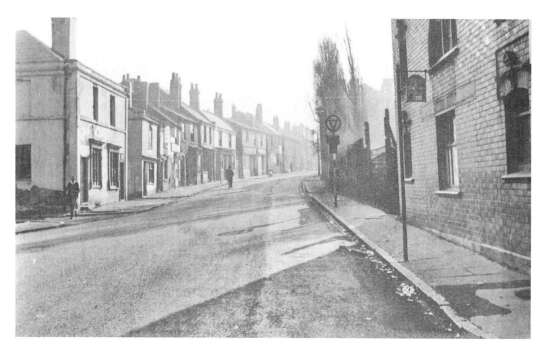

Bank Street, looking south from Salop Street. Part of the former Forum cinema is on the right. The old shops on the left had disappeared by the early 1960s, but the Forum building still remains as a snooker hall. (*Jack Smith*)

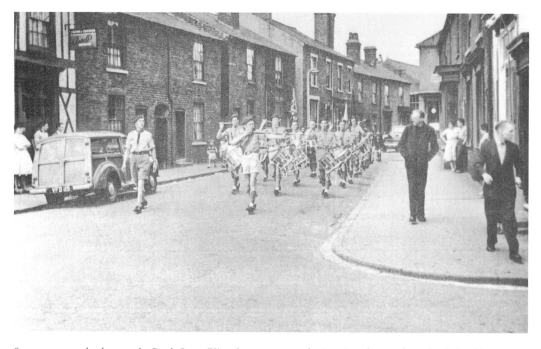

Scouts on parade close to the Bank Street/King Street crossroads. Ray Speed is on the right; behind him is Isaiah Martin. The Crown and Cushion public house is on the left. (*Jack Smith*)

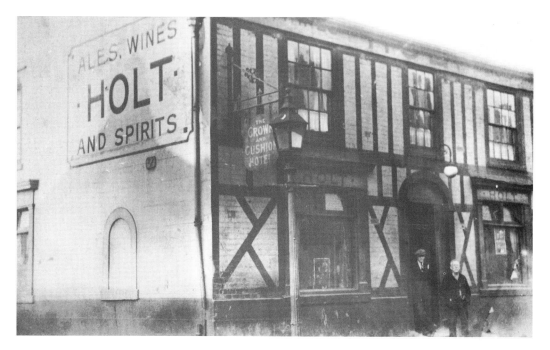

The Crown and Cushion, probably in the early 1930s. The landlord, Mr Todd Fellows, stands outside, his Gold-Garde (pocket watch and chain), a landlord's signature, proudly shown off, and his son Joe stands in the doorway. The Holt Brewery eventually came under the wing of Ansell's. (*Ron Davies collection*)

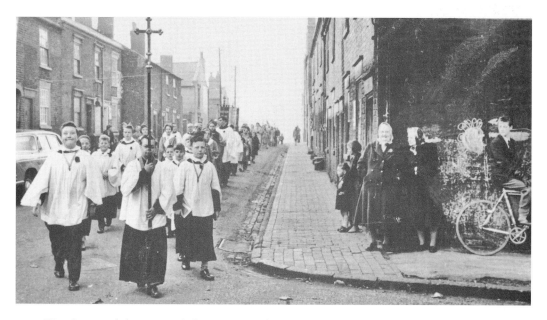

King Street and the corner of Slater Street, with St Martin's choir. Bearing the cross is Colin Edwards, and the ladies on the corner are Mrs Selman and Mrs Emily Davies. The lad standing with his bicycle is Alan Philpot. (*Jack Smith*)

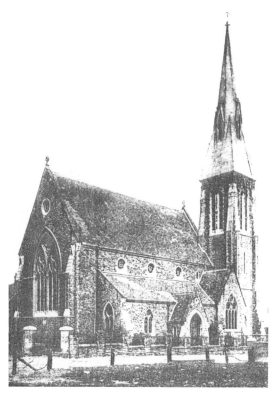

St Martin's church, *c.* 1906. Its high uncluttered broach spire was the envy of others for miles around. (*Roy Hawthorne collection*)

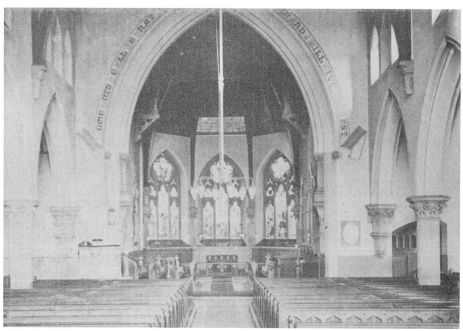

The interior of St Martin's church, probably 1920s. Over the gothic arch are written a few famous words from St Matthew's Gospel, chapter 11 verse 28. (*John Price*)

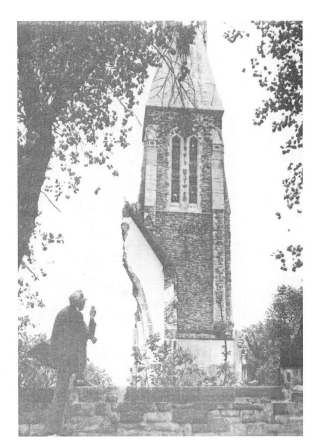

Professional photographer Reg Neville gazes towards the almost demolished St Martin's church, 1977. It was built during 1866-8 at the total cost of £6,000. (*Roy Hawthorne*)

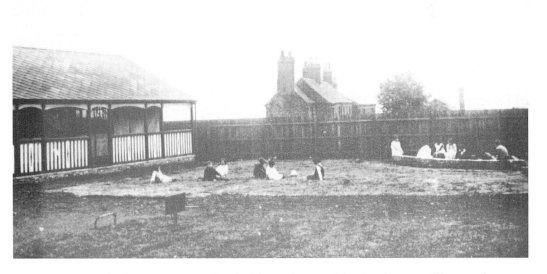

St Martin's School recreation grounds, which lay to the rear of the church, 1930s. Allotments have now taken over the site. The old houses are in Baldwin Street. (*Jack Smith*)

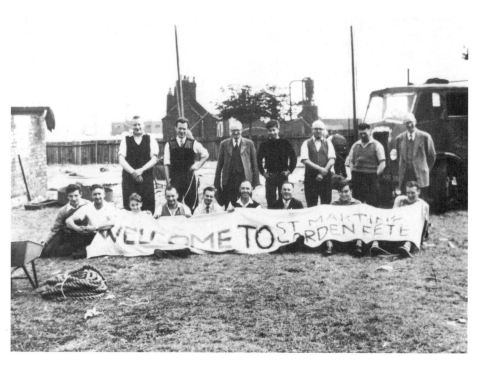

Members of St Martin's church at a garden fête in the recreation grounds, *c.* 1965. Back row, left to right: Frank Venton, -?-, -?-, -?-, -?-, Bill Dean, Ted Yeoman. Front row: -?-, Ray Shinton, -?-, Vic Vaughan, Colin Edwards,-?-, -?-, -?-, -?-. (*Jack Smith*)

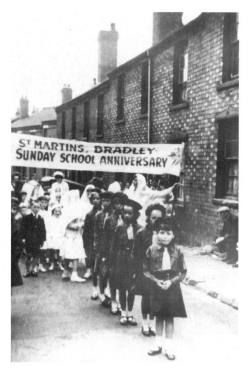

A Sunday school anniversary scene in Field Street, *c.* 1964. In the Brownies, third from the front, is Susan Unitt. (*Jack Smith*)

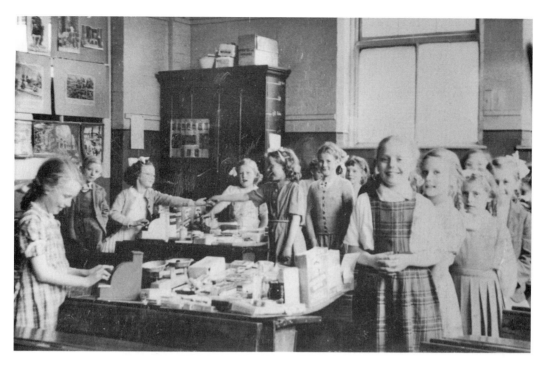

Mr Boydon's class at St Martin's School learning shopping skills, 1952. The young boy on the left must have felt out of place in the all-girl classroom. Included here are: V. Lloyd, K. Bowkley, K. Bunce, B. Smith, J. Bowkley, D. Smith, B. Pitt and Norma Hammond. (*Mrs N. Bradley*)

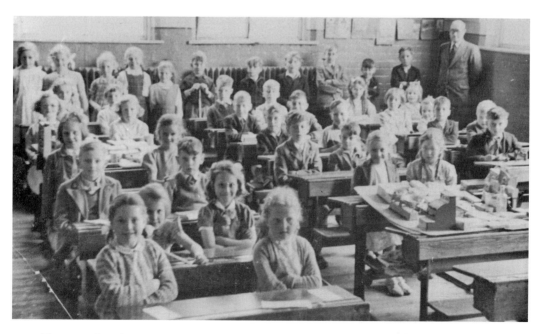

The same class, but now sitting at their desks. Mr Boydon is standing at the back of the class in the right-hand corner. (*Mrs N. Bradley*)

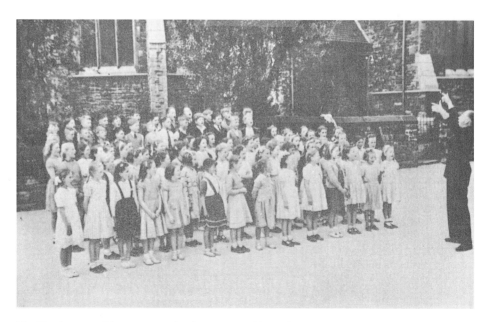

The Headmaster of St Martin's School, H. R. Arnold, conducting the choir of boys and girls, early 1950s. The church stands in the background. (*Mrs N. Bradley*)

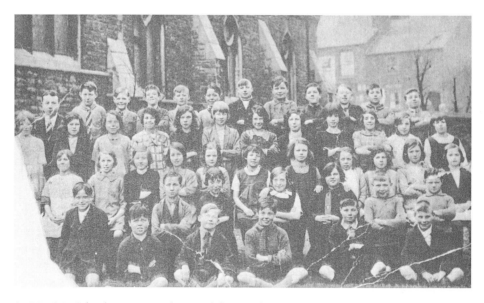

St Martin's School, 1920s. Back row, left to right: student teacher Tom Cope, S. Rudge, J. Siddems, A. Jober, S. Elwell, J. Downs, H. Greaves, G. Rowley, E. Phillips, T. Boucher, R. Dean, -?-. Fourth row: P. Goody, E. King, E. Barker, M. Garner, E. Grainger, M. Hargreaves, F. Beach, L. Hollington, I. Morris, E. Farrington, F. Blakemore, G. Edwards. Third row: A. Blackham, L. Smith, E. Fletcher, N. Price, H. Simkins, H. Smith, F. Wellings, H. Elwell, M. Bryan, A. Page, C. Davies. Second row: ? Simkins, ? Phillips, Kath Morgan, Minnie Caddick, Mary Eagles, Arthur Henderson, Joe Turner. Others named but not identified include: ? Soloman, ? Steadman, ? Russell and George Meese. (*Mrs N. Bradley*)

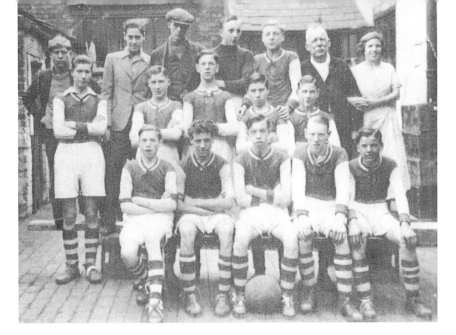

St Martin's boys' football team, towards the end of the 1930s. The photograph was taken at the Crown and Cushion, Bank Street. Todd Fellows was the licensee during this period and he allowed the team to assemble there; the goalposts were also stored at the premises and the team had to carry them to whichever pitch they used for the match. Back row, left to right: G. Fellows (son of Todd), Ralph ?, ? Kitman, R. Mitton, ? Ives, Todd Fellows and his daughter. Second row: ? Bicknell, J. Goody, J. Perkins, Bill Shorthouse, A. Stokes. Front row: ? Shaw, J. Rolph, J. Wellings (captain), ? Wilson, A. Skinner. The young Bill Shorthouse later went on to play for Wolves. (*Bill Shorthouse*)

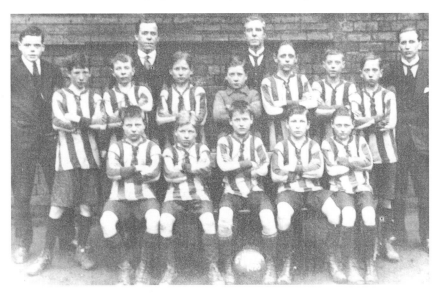

St Martin's School football team, 1920. Back row, left to right: teachers R. Earp, Mr Brightman, Mr Danks (Headmaster), -?-. Middle row, centre: S. Malkin (goalkeeper). Front row, centre: George Elliman (with ball); he played in the Bilston schools league. (*Roy Hawthorne collection*)

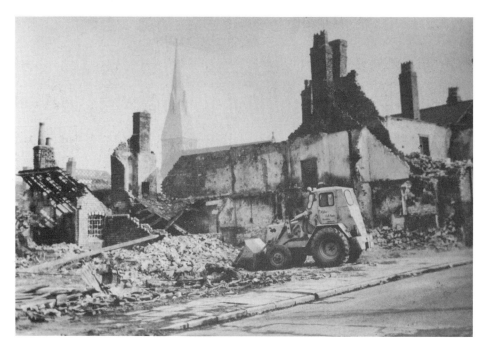

The demolition of Bank Street in progress, *c.* 1965. This revealed a view of the spire of St Martin's church. (*Jack Smith*)

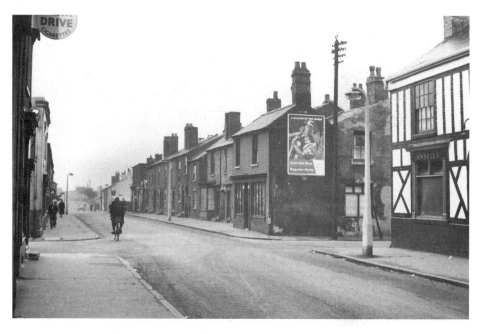

Looking south along Bank Street from King Street towards the memorial cross in the distance, *c.* 1964. The man on the bicycle is Albert Hawthorn. (*Jack Smith*)

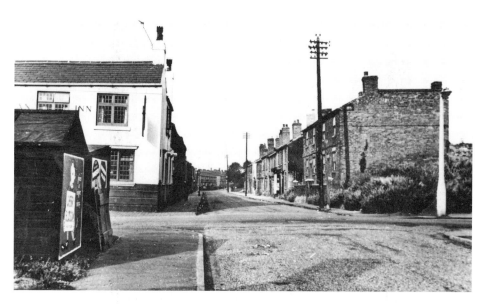

Looking down Lord Street from Jordan Place, *c.* 1965. Bradbury's shop is about halfway down on the right-hand side, and the wooden hut partly visible on the left is Dave's Groceries. (*Jack Smith*)

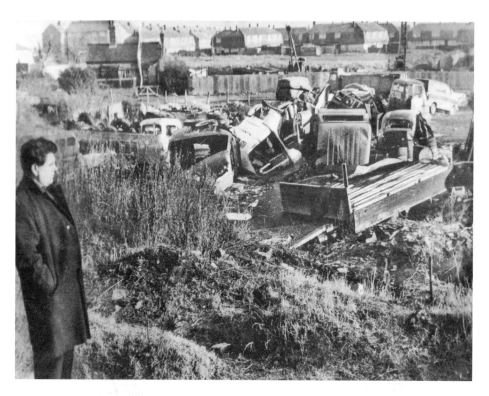

Councillor Dennis Turner stands on the derelict site that is acknowledged as the area where one of John Wilkinson's blast furnaces stood. It is situated off Walter Road, and was an eyesore in the late 1960s when this picture was taken. The area was later cleaned up and the new Wilkinson School built on the site. (*Wolverhampton Express & Star*)

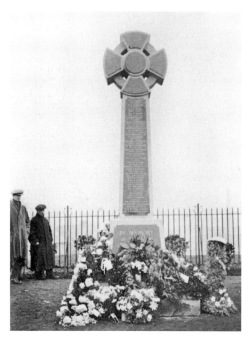

'In Flanders Fields'

In Flanders fields the poppies grow
Between the crosses row on row,
That mark our place: and in the sky
the larks, still bravely singing, fly
Scarce heard amid the guns below.

We are the Dead. Short days ago
we lived, felt dawn, saw the sunset glow,
Loved and were loved, and now we lie
in Flanders fields.

John McRae

Bradley War Memorial was erected in 1919 or 1920. Ordinary wreaths and flowers were placed here before poppies were taken up as the national remembrance flower. In the early winter of 1915 Colonel John McRae, a Canadian academic and volunteer medical officer, who following the second battle of Ypres found time, after treating the appalling casualties, to write a poem about the poppies' imagery. He sent it anonymously to *Punch*, and it was published on 15 December. The poem was reprinted around the world. In Georgia in the USA, Moina Michael, a worker with the YMCA, was so moved she vowed to wear a poppy evermore. In 1921 the British Legion was formed, and was approached by a YMCA friend of Moina Michael with samples of artificial poppies she had made. The idea of a Poppy Day, marking the anniversary of the Armistice, took off immediately (information from *Flora Britannica*, Richard Mabey). (*John Price*)

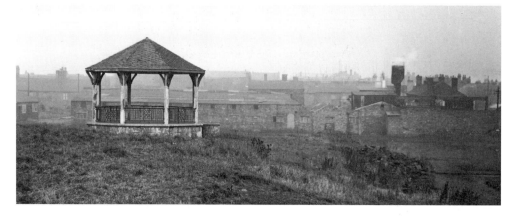

A 1960s view of the bandstand (the 'banner') in Memorial Park, also showing in the background the extent of the Niagra Foundry, and on the extreme left a little of the Memorial Park pavilion. This building originally belonged to the Cannon Iron Works and was used by its workforce for dances and other social activities. (*Wolverhampton Express & Star*)

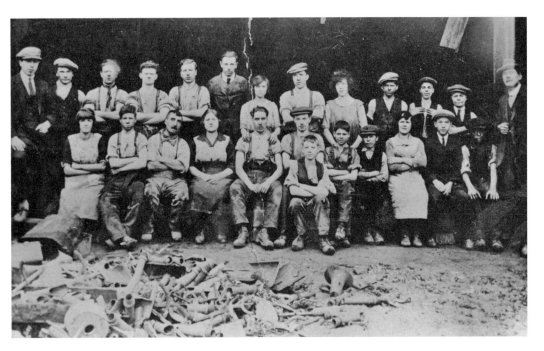

A group of workers at the Niagra Foundry, c. 1930. The lady on the left of the front row is Mrs Lizzy Perks, and the third from left is Ike Beasley, foreman. The tall person in the centre of the back row is Jack Smith, and the couple eighth and ninth from the left on the back row are Alf Wilcox and his sister Ethel. The gentleman on the extreme right is Mr Bucannon who owned the foundry. (*Mrs A. Whitehouse*)

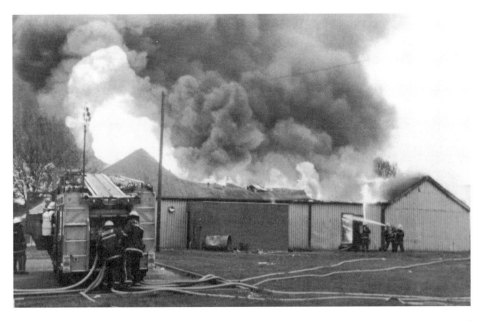

This dreadful act of arson destroyed not only the Memorial Park pavilion but also a piece of Cannon Foundry history, March-April 1997. (*Kath Whitehouse*)

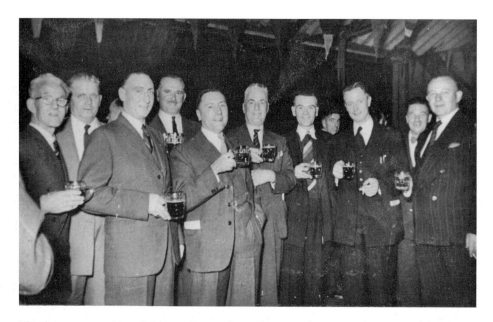

This happy group is probably made up of mostly ex-service men, who were celebrating at the British Legion Club in Perry Street, 1965/6. The building stood on the Memorial Park on the right of the bandstand; it previously belonged to the Cannon Foundry. Included in this group are: Mr Goodman (senior representative of Butler's Brewery), Jack Hayward, Major Jim Salt, Howard Shepherd, Dick Shortridge and George Coulson. (*Jim Salt*)

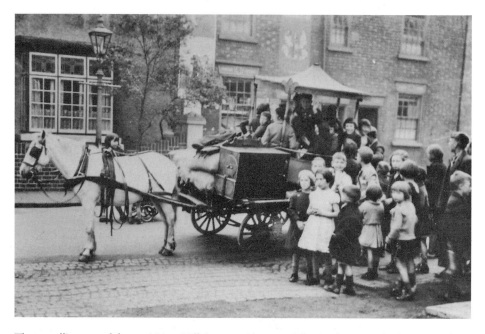

The travelling roundabout visiting Hill Street, mid-1930s. The machine was built on to a four-wheeled flat or float and manually operated. It was a delight for the local children who would pay a small charge for the ride. (*Wolverhampton Archives*)

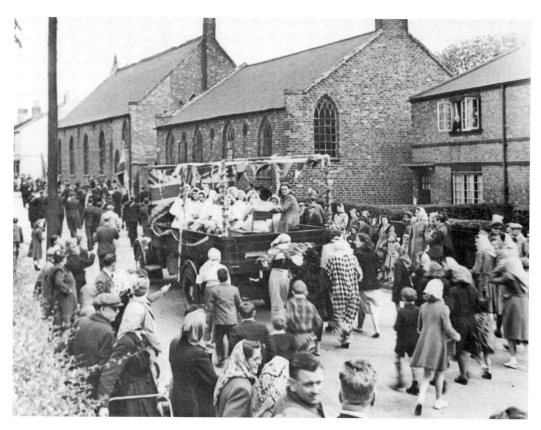

A busy carnival scene in Lord Street West, 1951. On the extreme left of the picture is the Railway Tavern. The largest building here is the Methodist chapel; attached to it is the Methodist school. (*Walker & Wootton*)

This float at Bradley carnival in 1951, carrying mostly young girls, is different from the others. It belongs to the horse and cart days, with its steel-rimmed wheels and crude braking system. The young lad on the extreme right is Colin Clarke, who with the rest of his friends looks very pensive. (*Walker & Wootton*)

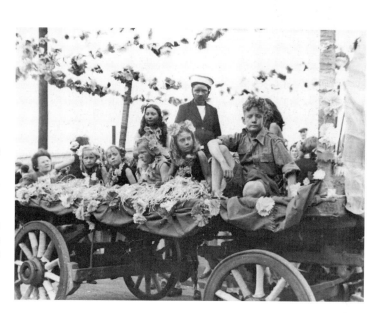

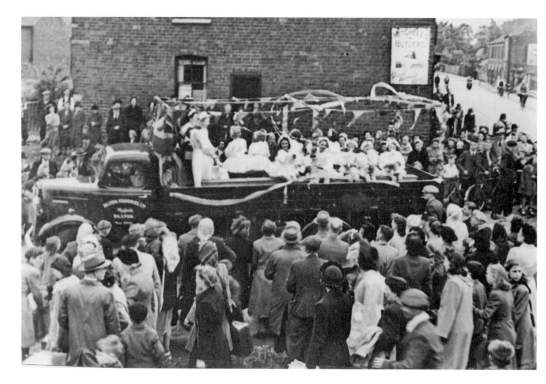

This carnival scene captures the corner of Lord Street West and Ash Street, 1951. The row of old houses in Ash Street stood next to Daisy Bank Schools. The dominating building in the background is Pru Maddox's grocery and off licence, which sports a Mitchell's and Butler's enamel sign; this shows their leaping deer trademark and the caption 'Good Honest Beer'. The gap to the left of the building led into Hall Green Street via Pump Yard and John Street. (*Walker & Wootton*)

Still with the carnival, these onlookers include Mavis Philpotts, Kathy Broadley, Brenda Lilley, Grace Shinton, Sheila Ward, Albert Piper, Clara Clarke, Grace Dugmore, and Lizzie Fellows, 1951. The cases the girls are carrying contain their fancy dresses. (*Walker & Wootton*)

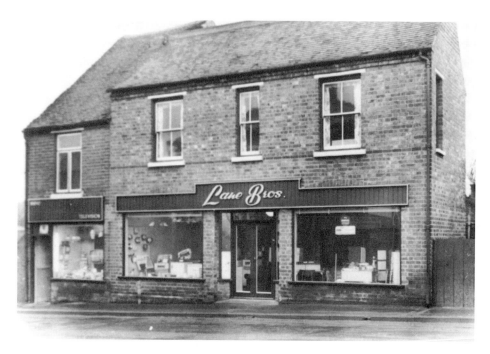

Lane's electrical shop in Ash Street, 1970. The shop sold expensive commodities but the windows never had to be shuttered then as they do today. (*Sheila Edwards*)

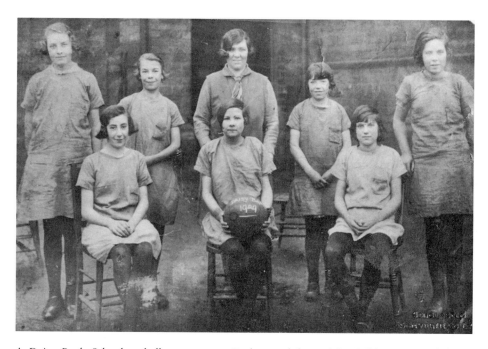

A Daisy Bank School netball team, 1929. Back row, left to right: Hilda Hoove, Elizabeth Hotchkiss, Miss Dodd, Francis Speed, Rose Henshaw. Front row: Doris North, Lily Sutton and Phyllis Thompson. (*A. Wootton*)

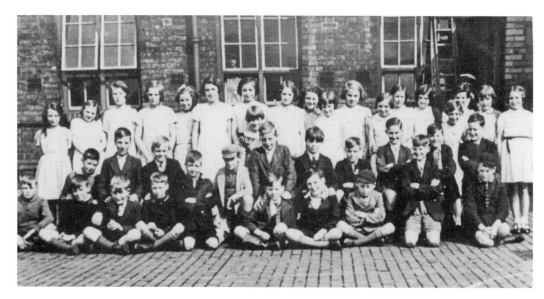

A group of Daisy Bank School scholars, 1938. Back row, left to right: Bessie Hale, Iris Elwell, Doreen Strong, Joan Bennion, Dora Fido, Joyce Horton, Adelaide Ellemon, Gladys Banker, Mary Pitt, Joan Elwell, Ollwyn Greenfield, Freda Richards, Iris Middleson, Doreen Crowther, Mabel Newman, Winnie James, Iris Lane. Second row: Clara Sefton (standing), Sidney Clark, Henry Billingsley, Bernard Francis, Fredrick Hackett, William Pearce, Walter Underwood, Arthur Griffiths, Arthur Baker, Dennis King, Joseph Morgan, James Salt. The front row includes: George Bateman, Dennis Potts, Arthur Brown, Samuel Rudge, Patrick Gair, Albert Fellows, Arthur Glover, Harold Newell. (*A. Wootton*)

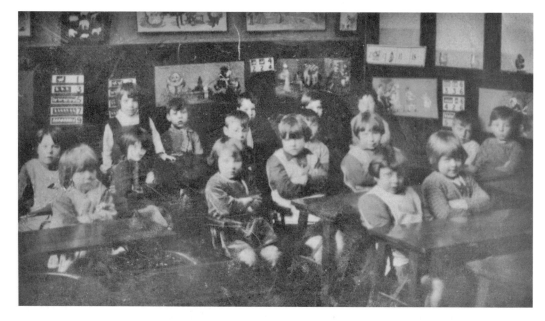

Daisy Bank School, 1931. The two girls on the left are Edith Potts and Lilly Barrett, and the girl standing with her hand on the desk is Connie Higgs. Boys along the back and side are Joe Bolton, Don Vaughan, Joe Bateman, Tom Smith, ? Price and Vernon Richards. Others include: Nancy Durant, Ted Jacques and Ken Smith. On the front row, second from left, is Phyllis Collins. (*Gwen Cooper*)

Another view of Daisy Street features little Julie Palmer in the foreground, 1962. Behind is the lodge and gates of Udall's field leading round the corner to Breakwell's Garage and the railway station. (*K. Palmer*)

Mr Ken Palmer cleaning the windows of the family business shop in Daisy Street, Daisy Bank, *c.* 1949. The Mooday family had previously traded there since the nineteenth century before Mr Charles Palmer took over in 1920. It traded as both a grocery store and a barber's shop and was known locally as 'Charlie the Barber's'. The hairdressing finished in about 1951 but Ken continued there until 1960. It was one of the first shops to sell newspapers in the Bradley area. (*K. Palmer*)

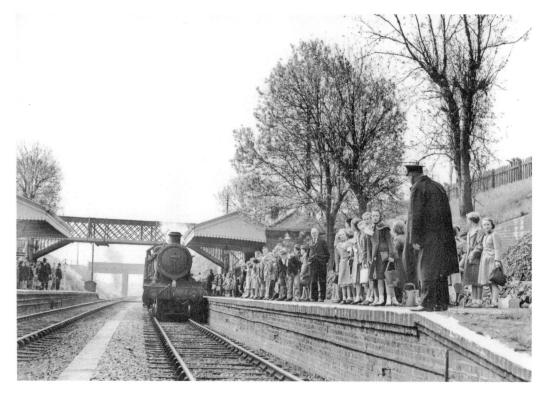

During the summer of 1962 train services on the Bilston West, Bradley and Daisy Bank line ended. It had previously been used by local businessmen. Ambrose Roberts, who was blind, would collect his milk churns from Daisy Bank station and deliver the milk on foot to households from his business premises at 27 Wesley Street. This picture dates from 1956 and shows children leaving on a trip financed by the J. L. Greenway Trust. Mr James Luther Greenway had an iron works in Edward Street, Bradley, which was later renamed Greenway Road. Mr Greenway donated the children's playing fields in Bankfield Road, Bradley, in 1930, and later created another play area in Trinity Road, Bilston. In 1937 he set up a scheme to provide seaside trips for children, and the Trust developed from this. (*Wolverhampton Archives*)

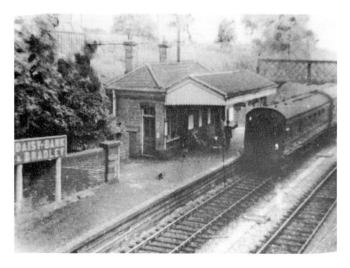

Another view of Daisy Bank and Bradley railway station, 28 July 1962. It shows the 5 p.m. passenger train to Dudley. This was the last day of public transport on this line. (*R. Squire*)

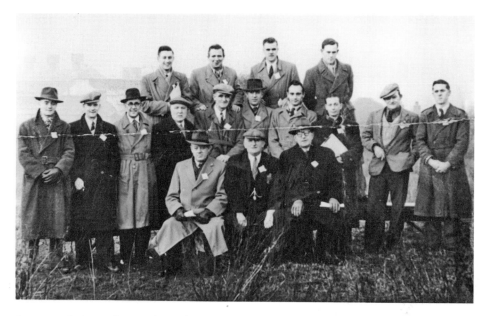

A group of pigeon fanciers from the Old Bush public house in Skidmore Road, Daisy Bank, *c.* 1960. The inn was kept by Joseph Adams, who produced excellent home-brewed ales from 1928 to 1963. Named in this group are: back row, second from the left, Joe Green. Middle row, second from the left, Tom Jones; third left, Tom Cordwell, ninth left, Joe Woolley. Front row, first left, Joe Ward; second left, Joe Adams. (*M. Tilley*)

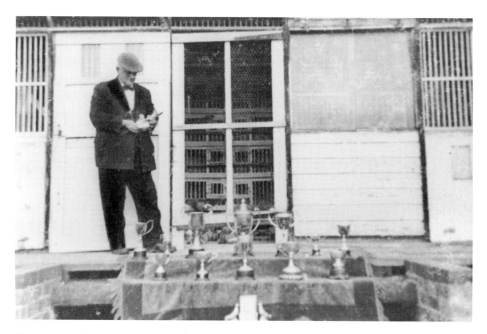

This picture shows Joe Adams outside his pigeon loft, which stood opposite his pub, *c.* 1960. In front of him are some of the many cups and trophies he had won. The place was a mecca for pigeon lovers, who would travel from all corners of the country to meet and compete. (*M. Tilley*)

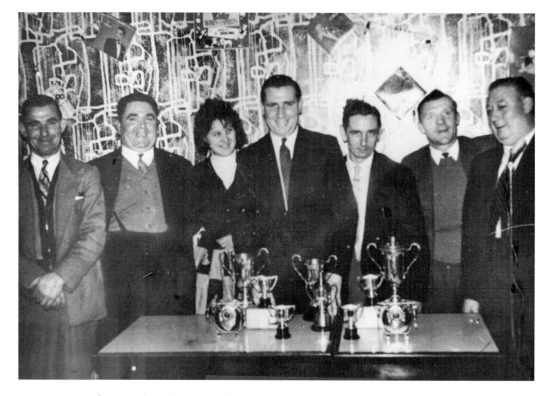

A presentation of cups and trophies was held at the Ship and Rainbow, Rainbow Street, Highfields, in 1962. Wolves star Bill Shorthouse was guest of honour and presented the awards. Pictured here, from left to right, are Z. Allen, S. Phillips, A. Worsey, Bill Shorthouse, E. Worsey, G. Allen and P. Squire. (*P. Squire*)

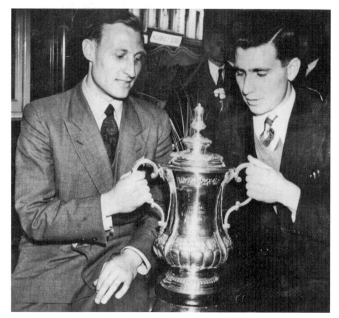

Two famous Bradley lads seen here are Bert (the Big Cat) Williams and Bill (the Baron) Shorthouse. Both played for Wolverhampton Wanderers during the glory years of the 1940s and '50s. Bert was capped many times for England. Bill was wounded during the Normandy landings on D-Day. Bert and Bill are holding the 1949 cup which they won that year, beating Leicester 3-1. Both retired in 1957 and received a silver tray from the people of Wolverhampton in recognition of their achievement. (*Bill Shorthouse*)

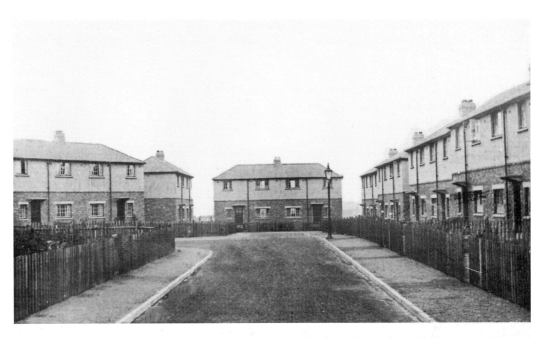

Udall Road, Highfields Estate, 1930s. The gas light is clearly visible on the right. These council houses were some of the first to be built during the 1920s and are characteristic with their picket-type fences and metal window frames. (*A. Rea*)

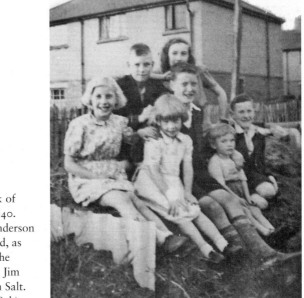

The Bartley family pictured at the back of Davies Avenue, Highfields Estate. *c.* 1940. They are sitting on top of their new Anderson air-raid shelter, which they were to need, as bombs were dropped within yards of the estate. Back row, left to right: Barbara, Jim and Yvonne; in front is their friend Jim Salt. Front row: Pat, little Don and Bill. (*J. Salt*)

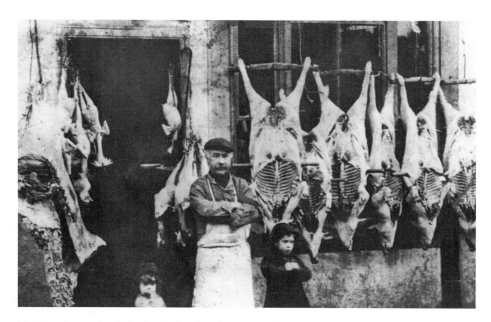

The Hawthorne family had traded as butchers in Bradley since the nineteenth century. This is an early but rather gruesome picture, taken in 1910 at 57 Hall Green Street, Bradley. It shows the proprietor Samuel Hawthorne with sons, two-year-old Frank on the left and four-year-old Ray on the right. (*Roy Hawthorne*)

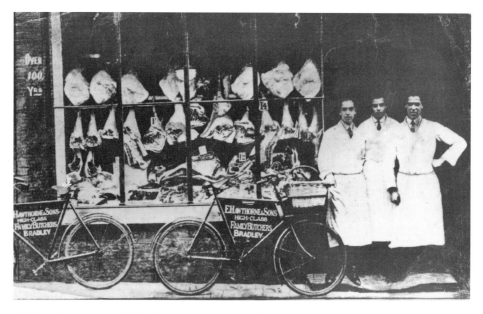

A bigger shop at 67-8 Hall Green Street, 1926. After Samuel's death in 1925 the shop traded under his wife's name, Emma Hawthorne and Sons. Meat was bought live on the hoof and slaughtered on the premises at the rear of the shop. The three sons seen here are Frank, Allan and Ray on the extreme right. (*Roy Hawthorne*)

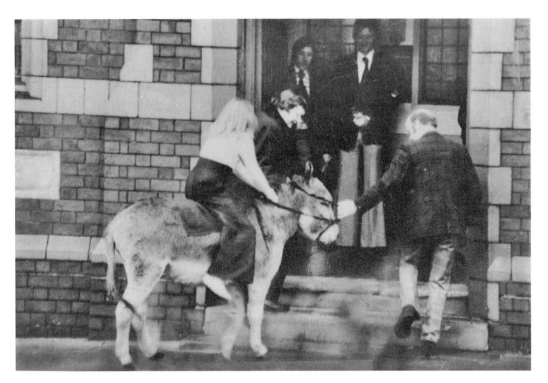

Taking the donkey to church – outside the old Wesleyan chapel. Leading the donkey is Alan Dolman, and the other helper on the left is Ken Brown. In the doorway on the left is Michael Dickinson and on the right is Roger Rudge. The girl astride the donkey is Jill Owen of Ladymoor. (*A. Wootton*)

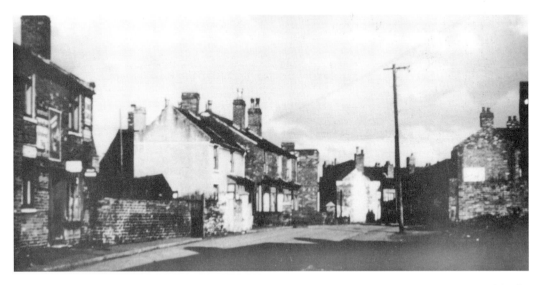

Looking east from Hall Green Street towards Cross Street, 1960s. It was here in the vicinity of the far white-gabled building iron master John Wilkinson stayed during visits to his iron works. Surprisingly, the only remaining feature to be seen here today is the telegraph pole. The shop on the immediate left was Barnsley's. (*Birmingham University*)

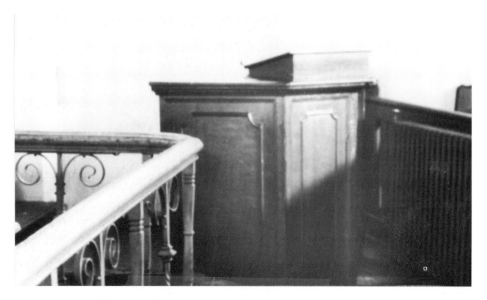

The noted John Wilkinson cast-iron pulpit is as it stood in the old terracotta church, 1975. As an iron master John Wilkinson's name was legendary. He came to Bradley in the 1760s, liked what he saw and started to build the first blast furnace on the rural pastures here. It was the first furnace in the Black Country and the first to be blown independently of the streams that had always dominated this industry. To his workmen he was known as Squire Wilkinson, and as his works expanded and the population grew, there became a need for some spiritual guidance and the community asked John if he would build them a chapel. After some deliberation he said 'Yes, providing it is built of iron and comes within the scope of my Works.' It became known as the Cast Iron Chapel, the first of its kind in the world. The iron chapel may no longer exist but the cast-iron pulpit serves as a reminder of those early years. (*Ron Davies*)

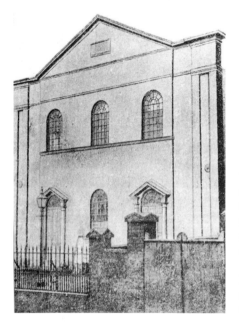

This church preceded the 1902 Wesleyan church and is seen here in 1888. It was built in 1835 to a classical design and was capable of seating 700 worshippers. In 1889 the front of the chapel was remodelled to include a capacious porch and vestibule; then in July 1901 it was struck by lightning and set ablaze. Fortunately, the chapel was heavily insured, allowing the building of the new church. (*Rita Evans*)

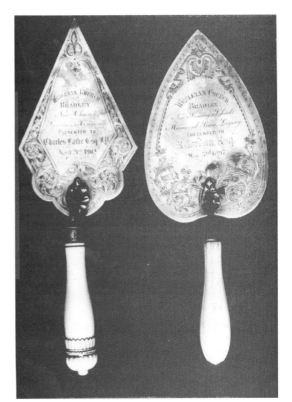

These two ceramic-handled trowels, now the property of the Wesleyan chapel, were presented to Charles Lathe (an industrialist who manufactured Claco Fire Grates, a commodity now much sought after at Tipton) for a stone-laying ceremony for the new church on 21 April 1902, and to Mr H. Jordan (also an industrialist, who had enamelling works at Bilston) for a memorial stone-laying ceremony for a new Sunday school on 3 May 1897. (*Ron Davies*)

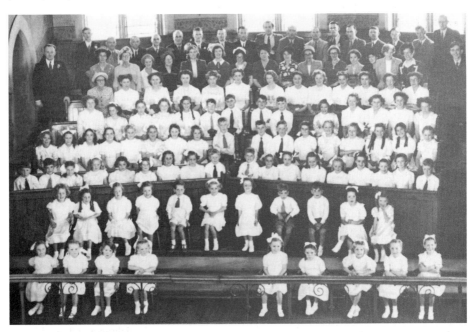

The Wesleyan Sunday school anniversary, *c.* 1946. The chapel had good congregations and this photograph shows about 116 members. Included are: B. Lowe, R. Fellows, J. Grinsill, M. Fownes, V. Fetcher and N. Hammond. (*R. Fellows*)

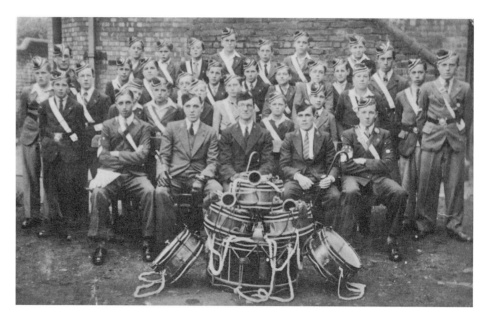

The Wesleyan Boys' Brigade posing at the rear of the church, 1940s. Recognisable faces seen here are front row, left to right: W. Hallmark, A. Beddow, A. Rogers and J. Newell. Others include: A. Gough, D. Bunce, J. Silvester, H. Dugmore and H. Newell. (*A. Gough*)

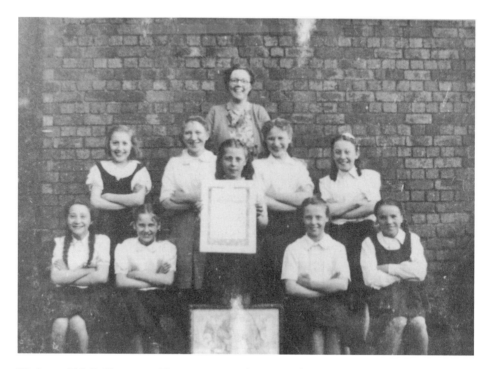

Wesleyan Girl Guides, 1946. The woman standing is V. Fletcher, the Guide leader. Back row, left to right: M. Woodcock, J. Boden, C. Boden, O. Dingley. Front row: M. Fownes, E. Smith, M. Howell, R. Bevan, J. Bough. (*C. and J. Boden*)

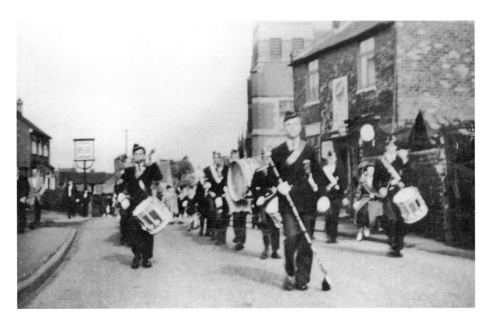

Looking down Hall Green Street towards Daisy Bank, *c.* 1959. The photograph shows Barnsley's old shop on the right and the Britannia Inn on the left. The Boys Brigade is parading towards Cross Street.(*R. Fellows*)

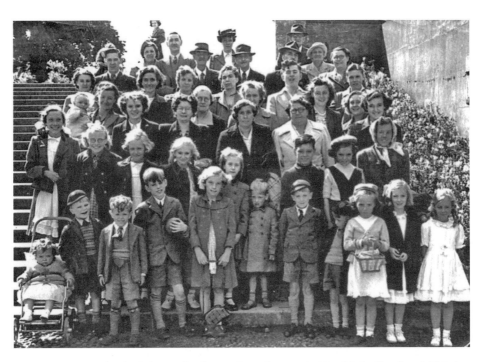

Hall Green Street also had the smaller but no less vibrant Primitive Methodist chapel. This is a Sunday school outing to Trentham Gardens, early 1950s. Among those in the group we can name Beryl Larkin, May Whitehouse, Eileen Dudley, Gwen Collins, Hilda Paddock and Mrs Ingram; also in the group are members of the Timmins, Rock, Thomas and Oseland families. (*Gwen Cooper*)

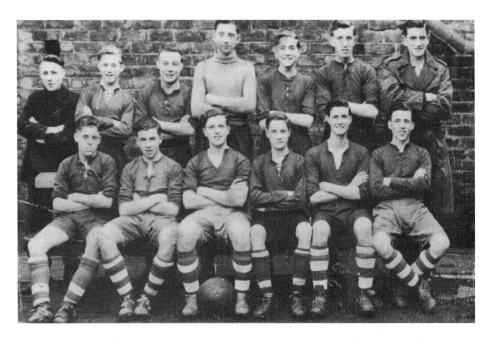

Wesleyan church football team, 1949. Back row, left to right: A. Rudge, W. Nock, W. Devey, G. Smith, R. Shorthouse, W. Owen, E. Owen. Front row: F. Gandy, H. Evans, W. Orton, R. Lewis, R. Butler, T. Rudge. (*W. Orton*)

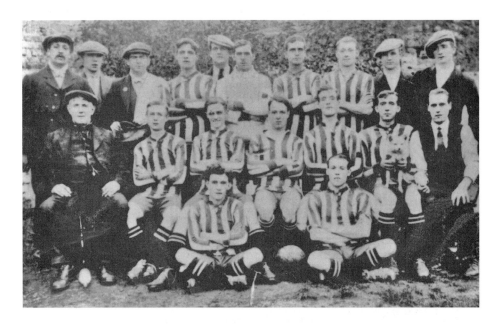

Bradley United FC, 1922. Back row, left to right: H. Haynes, W. Baker, T. Turner, W. Edwards, S. Bevan, S. Edwards, J. Jones, J. Howell, J. Messenger. Second row: W. Brown, J. Bond, C. Greenaway, D. Walton (captain), J. Hodson, B. Edwards, A. Weekes. Front row: W. Eldon, J. Rogers. Mr W. Brown was host at the British Oak in Wesley Street, Bradley, from 1916; he later moved to the Britannia in Hall Green Street. (*A. Wootton*)

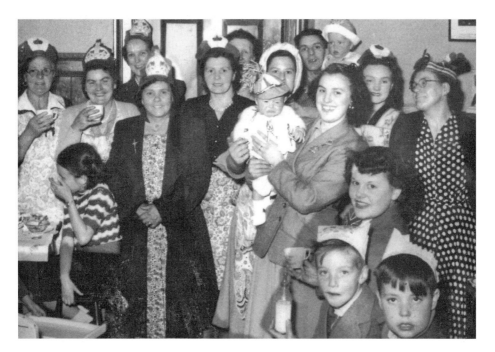

This picture was taken in the Crown Yard public house, Hall Green Street, to celebrate the 1953 Coronation. The lady in the dark coat wearing a crown is Mrs Louisa Collins, next on her right, holding a cup, is Mrs Harris, and the lady holding the baby is her daughter. (*Gwen Cooper*)

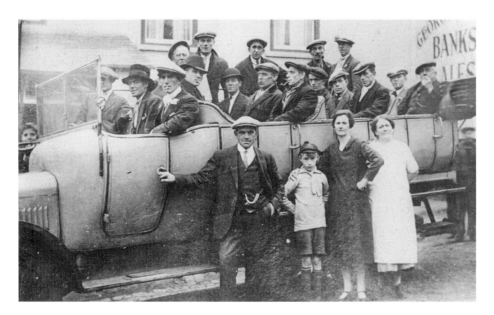

Ben Smith was a well-known businessman from Bank Street. He was the proprietor of both a greengrocery shop and a luxury coach tour company, making trips to the seaside, local beauty spots and weekly football matches. This photograph of 1928 was taken outside the George and Dragon Inn at Woottons Square, Hall Green Street. It is assumed this journey is to a local football match as all the passengers are male. (*Mrs N. Bradley*)

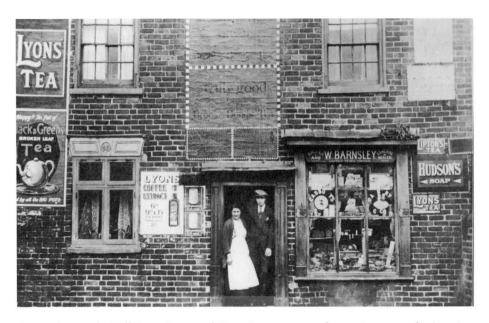

To complement the Hall Green Street and Cross Street scene on the previous page, this is a view of Barnsley's general groceries, with owners Bella Barnsley and her brother Cyril standing in the doorway, 1930. (*Jennifer Martin*)

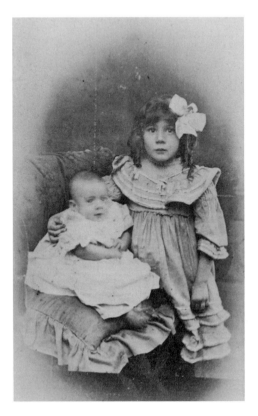

A lovely early portrait of Bella and Cyril Barnsley, 1907. (*Jennifer Martin*)

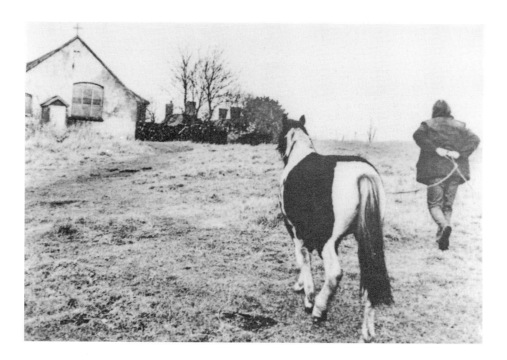

A pony being led across the 'Big Hilly' in front of St Aidan's Mission, 1970s. The green belt of land covered an area of about 13 acres and belonged to Bradley butcher Frank Hawthorne during the 1940s, before being acquired by Staffordshire Council. Part of it is now the new Hall Green cemetery. (*Wolverhampton Express & Star*)

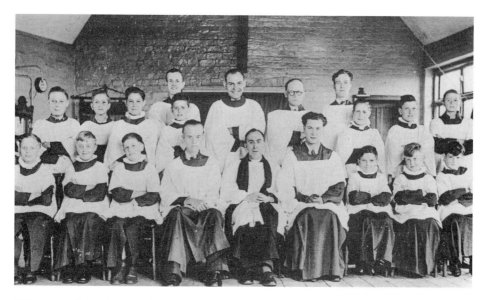

This group of choirboys inside St Aidan's Mission includes Billy Devey, Dennis Francis (standing at the back) and his father, wearing glasses. In the centre of the front row are Bernard Francis, Father Ensor and Jim Salt. Also included are Ray Ellis and Wilf Orton. (*Wolverhampton Archives*)

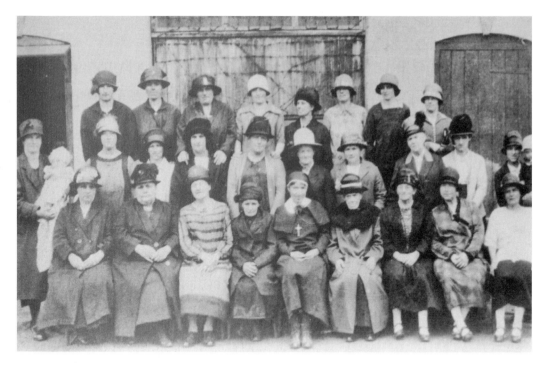

A group of ladies, all wearing hats, in front of St Aidan's Mission, 1924. Back row, left to right: ? Lewis, ? Lewis, -?-, -?-, ? Morris, ? Attwood, ? Wilde, ? Withers. Second row: Mrs Francis (holding baby Dennis), ? Blackburn, ? Amiss, -?-, ? Churms, -?-, -?-, ? Poultney, -?-, ? Downs (holding baby Wilfred). Front row: ? Rees, -?-, -?-, -?-, Deaconess Miss Grace Hodges, ? Sumner, ? Worsey, ? Ball, Louise Davies. St Aidan's two sister missions were St Cuthbert's at Wallbrook and St Oswald's in Ladymoor. (*Wolverhampton Archives*)

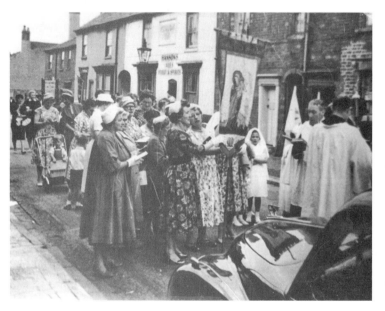

A rare view of Hill Street, with ladies from St Martin's church on an anniversary parade, 1960. Some of the ladies known are Mrs Grinsell, Mrs Davies and Mrs Jeffreys, and conducting the sermon is T. Davies, choirmaster. (*Jack Smith*)

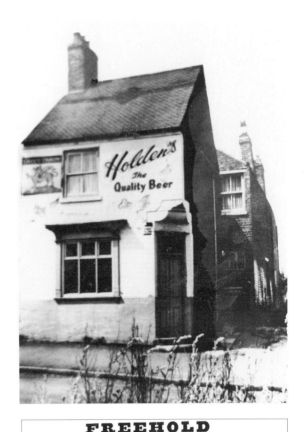

The Green Dragon public house in Cross Street, 1969.
(*Wolverhampton Corporation*)

An 1853 notice advertising building land for sale in what is now Wesley Street. It gives some idea of when the street was first established. (*Bilston Library*)

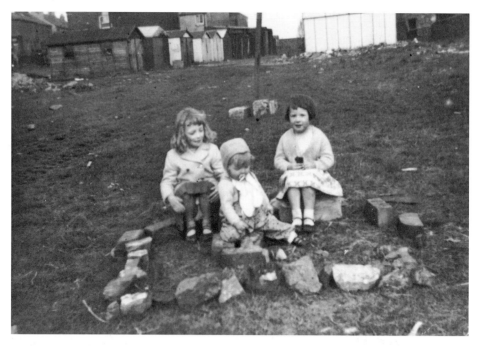

The most poignant and beautiful picture in this book shows Mr Hallmark's field in Cross Street, 1960s. The beauty comes from the children, who in a world of their own safely play at houses, just a few bricks and stones placed to resemble the shape of a house, with a gap for a doorway and a simple fire-place containing a few sticks and perhaps a lump of coal – such happiness that children of today will never know. Other popular games were shops, or mothers and fathers. Note the garages in the background: no parking in the streets at night without lights then. (*P. Squire*)

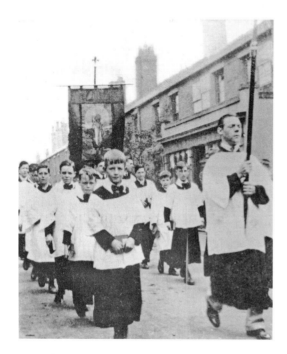

St Aidan's Mission procession on its way down Wesley Street, 1932. Probert's shop can be seen in the background. The choir would be led by Boy Scouts playing their drums and bugles, and a street collection would be taken. Included in the procession are D. Francis, H. Wild, H. Jones, W. Elwell, ? Stanford, E. Long and A. Gough. (*Wolverhampton Archives*)

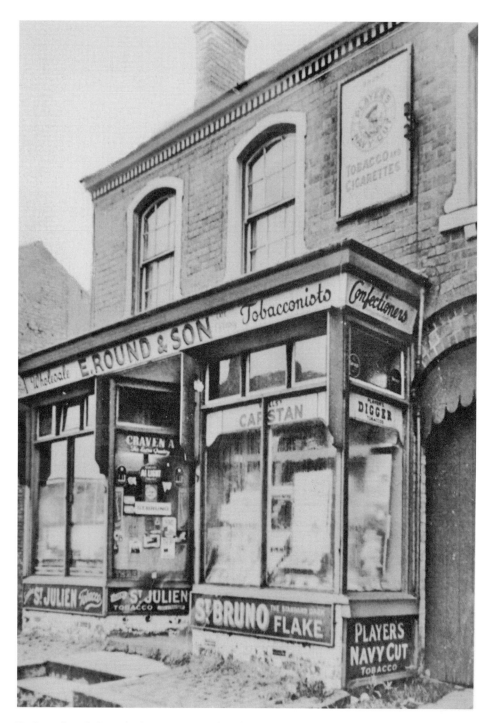

E. Round and Son, Wesley Street, 1960s. This picture shows one of the more impressive business frontages in the area; the building was originally the residence of the various Wesleyan ministers. In 1924 the property was listed as the business premises of Mr E. J. Worsey. (*Wolverhampton Express & Star*)

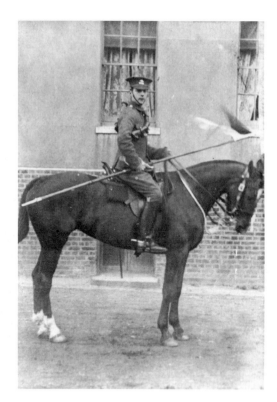

Bradley born and bred was Lancer Jim Salt, seen here in 1915 at Tidworth Barracks. He served in both world wars, winning the Military Cross and the Italian Medal of Valour. He attained the rank of major. (*J. Salt*)

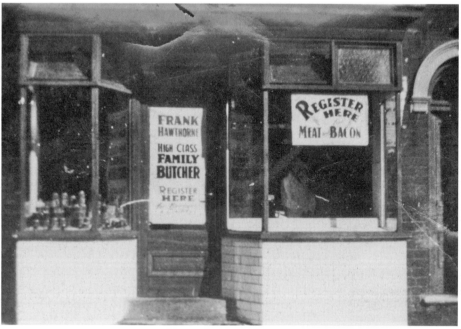

Frank Hawthorne's butcher's shop at 18 Wesley Street, in the early 1950s when rationing was still in force. The premises were occupied in the 1920s by Stephen Williams, who was a beer retailer. (*Roy Hawthorne*)

Bradley folk enjoying a drink in the British Oak, Wesley Street. Left to right: Violet Turton, Edgar Squire, Lassie Camm and Sammy Sanders. Picture dates back to the 1950s. The Iron Master public house now stands on the site. (*Roy Hawthorne*)

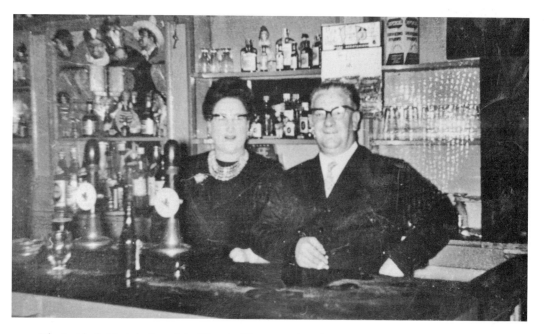

The Smiths behind the bar of the Victoria. They moved to the premises in 1962, having previously kept the Rifle Corps at Hurst Hill. The Victoria was first a Bents pub and then became M & B. The Smiths left in 1970 just before demolition. (*J. Smith*)

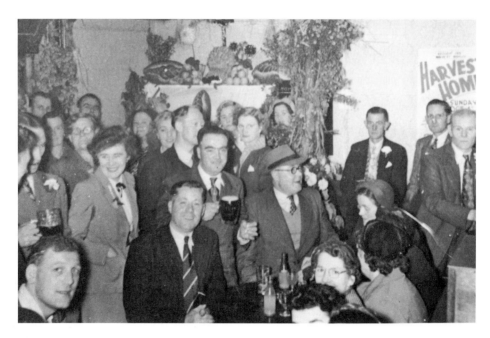

The interior of the Victoria, *c.* 1955. Note the harvest festival collection of fruit and vegetables displayed behind a crowd of regulars celebrating the occasion. Included in the group are: T. McGarry, K. Stanford, S. Wynn, L. Wynn, J. Tonks, S. Tonks, J. Ellis, E. Ellis, W. Hewins, S. Darby and H. Bradbourne. (*R. Fellows*)

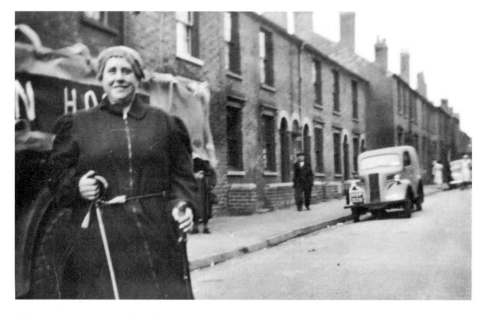

The Coronation carnival, Wesley Street, 1953. Mrs Sally Hewins is dressed as Friar Tuck and there is a carnival lorry behind her. In the background is Harold Davies' van standing outside the family shop: he was the local handyman who repaired radios, bicycles, charged accumulators and fitted household plug sockets. Walking down the street is Mr Camm. (*R. Fellows*)

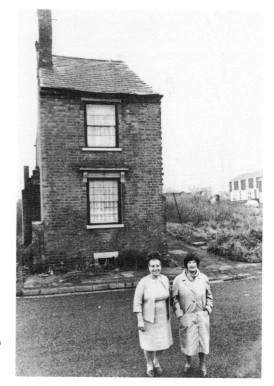

Gordon (left) and Graham Mason in their
father's lorry at the family coal and haulier
business at 73 Wesley Street, 1940. The firm
had started business in Hill Street, Bradley, in
1924 with horse and cart transport. Note the
screened headlight on the Bedford vehicle: this
was part of the blackout regulations.
(*A. Mason*)

One of the last houses to be demolished in
Wesley Street was No. 79. The owner Mrs M.
Fownes is seen here on the left with Mrs E.
Rogers in 1971. The property once belonged to
Lady Foley, whose family owned coal mines in
the area. (*R. Fellows*)

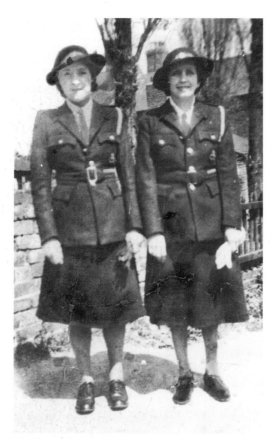

Mrs T. Cooper (left) and Mrs E. Higgs in their ARP uniforms, 1940. They had to report on two nights each week for training at their headquarters in Harding Street, Daisy Bank. This picture was taken in the back garden of 58 Wesley Street. The two ladies were soon to become very busy with the Blitz – Nazi bombs fell frequently in the area, houses were damaged, people suffered and some lives were lost. (C. Higgs)

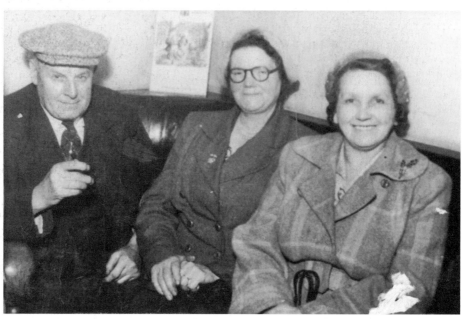

Mr and Mrs E. Ruby and Mrs Higgs enjoying a drink in the Victoria, 1950s. (Mrs A. Whitehouse)

Proud grandfather Mr T. Faulkner holding his young grandson Lee outside the Victoria, Wesley Street, 1962. The whole street was demolished in 1972. (*R. Faulkner*)

Wesley Street children attending the fifth birthday party of Royston Squire, 1951. Standing at the back is Bobby Stanford and next to him with false nose and cap is P. Squire, on the extreme right is N. Thomas. Second row, left to right: G. Calloway, P. Thomas, A. Richards, V. Brooks, P. Caddick, L. Edge. Front row: B. Haywood, B. Mason, -?-. (*Roy Hawthorne*)

It would seem from the following pictures that everyone loved a tea party in the days when the old streets existed, whether they were held in churches, pubs or private homes. These days people are more isolated from their neighbours. This group is enjoying the 1953 Coronation party at the Wesleyan chapel, and includes T. Jacques, Alice and Ann Wynn, T. McGarry, J. Ellis and Mrs Stanford. (*Walker & Wootton*)

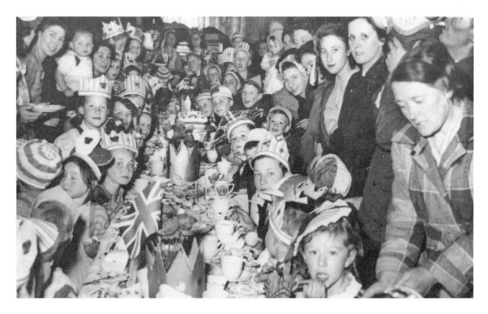

Another group enjoying a carnival tea party at the Wesleyan school to celebrate the 1953 Coronation. On the extreme right at the front is Mrs Darby; others included are: V. Brooks, M. Squire, L. Mason and J. Tomasin. (*Walker & Wootton*)

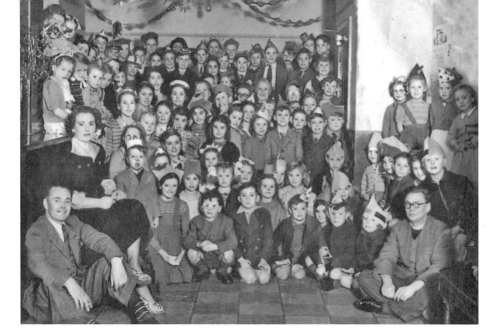

Another tea party in the neighbouring Hill Street, early 1950s. This time the happy group is partying at the Bird in Hand. It appears to be a Christmas party as the local vicar is seen seated in the bottom right-hand corner. Also included are: Bobby Stanford, Allan Collins, Janet Southall, Miss York, Lily Shepherd and the twin girls Alice and Ann Wynn. (*Gwen Cooper*)

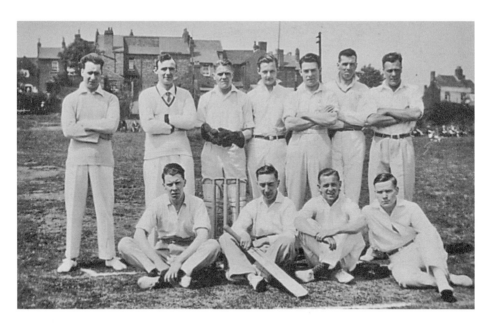

Local cricketers on the Bradley-Wesley cricket square, summer 1932. It was also used as a football pitch. The ground behind this was called the Cuckoo Field and was used by Bradley United FC. The cricket square land housed an army camp during the war, with an anti-aircraft gun and a battery of search lights that were used during local air raids. The houses in the background are in Brierley Lane. The team represented Sankey's Bank Field Works. Standing, left to right: Albert Hill, Tom Walker, George Aston, Harry Shepherd, Joe Churm, Arthur Price, Norman Astbury. Seated: Arthur Southall, Frank Screen, Geoff Cave, Jack Tabner. (*H. Shepherd*)

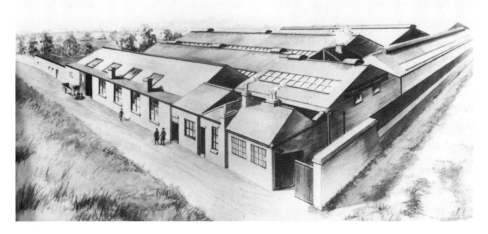

A birds-eye painting of the Star Foundry at Batman's Hill, later Matthews Foundry, *c.* 1920. It finally belonged to the Triplex Foundries. (*Roy Hawthorne*)

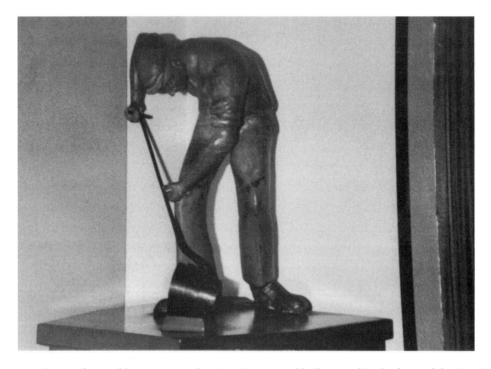

A sculpture of a moulder pouring molten iron into a mould. This stood in the foyer of the Star Foundry after Matthews Foundry took over in 1974. The sculpture was designed by Mr Trafford, who was Matthews' company secretary. (*Ron Davies*)

The Vogue Bath Works, Batman's Hill, formerly the British Bath Works in Highfields Road, shows off the last bath it produced in 1985; plastic and fibreglass had completely taken over this particular type of product. Cast-iron baths are now being manufactured again. Left to right: -?-, -?-, -?-, -?-, -?-, Roy Vaughan, Arthur Wootton, Alan Barker. (*A. Wootton*)

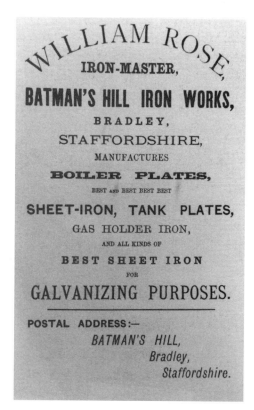

William Rose's advertisement of the iron products produced at his Batman's Hill Iron Works in about 1870. It is taken from Samuel Griffiths' *Griffiths' Guide to the Iron Trade of Great Britain*. (*Samuel Griffiths*)

This cottage-type building, the last of its kind, at least in Bradley, came to light when a high brick wall surrounding Tipper's Tube Works in Rose Street was demolished, *c.* 1990. It may earlier have served as offices to the works. The building was demolished soon afterwards. (*Ron Davies*)

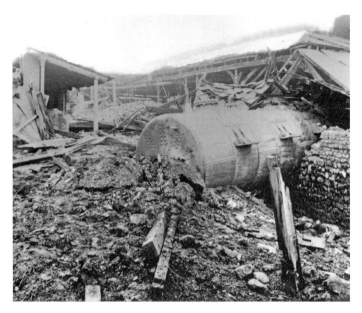

On 20 January 1903 an explosion occurred at Batman's Hill Iron Works. James Warren and Henry Southall were killed on the spot, while Richard Cooper and Edward Holloway died later in hospital. The boiler was of the Cornish type and made of wrought iron. Parts fell 45 yards away as a result of the high pressure of the steam. It was stated in the accident report that the boiler was twenty years old and had previously been patched up. (*Wolverhampton Archives*)

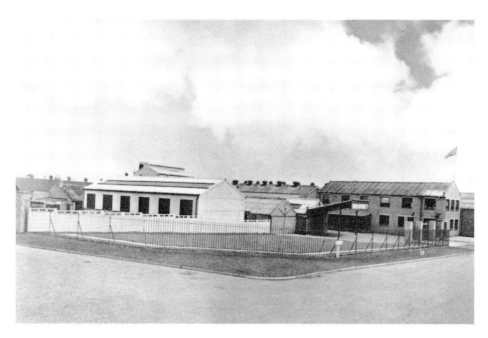

Edward Matthews Iron Foundry, on the corner of Wilkinson Avenue, to the left, and Cross Street, *c.* 1957. It was an ideal foundry, the most spick and span for its time, as the following pictures indicate. (*Edward Matthews Ltd*)

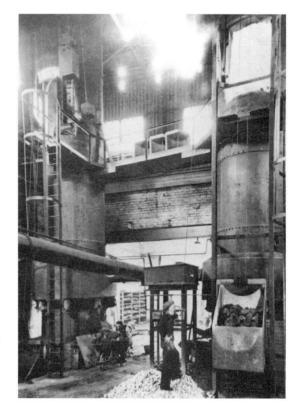

A scene in the cupola section of the works. The nearest furnace is about to receive a burden of coke and iron; the furnaceman is Bill Elwell. There were three furnaces in all: the two seen here were used for general castings, and there was a smaller one for special casts.
(*Edward Matthews Ltd*)

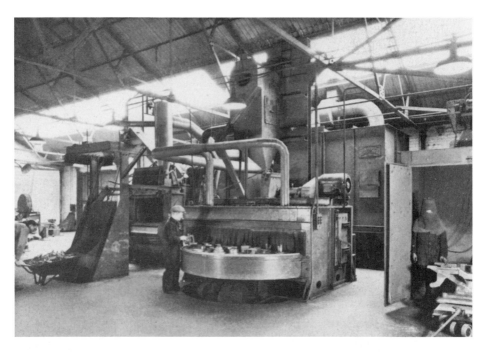

The shot-blast department. The heavily clothed and masked shadowy figure standing to the right of the picture is Herbert Fido, and standing by the centre shot-blasting machine is Ted Wilkes. (*Edward Matthews Ltd*)

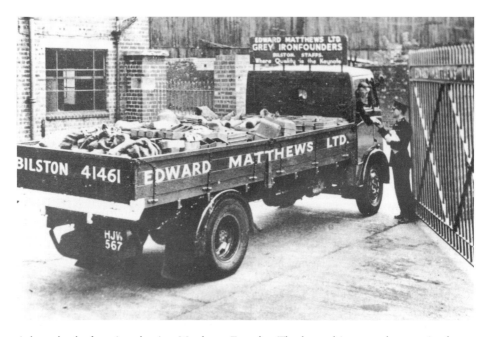

A lorry load of castings leaving Matthews Foundry. The lorry driver was known simply as Bill; the security guard is Joe Elsender. The lorry is spotless, typical of the works in general. (*Edward Matthews Ltd*)

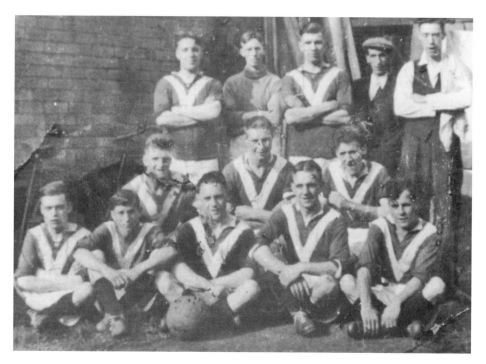

Edward Matthews Foundry was represented in 1937 by this football team, which picked up a few trophies along the way. The gentleman standing in the back row is their secretary and trainer, as is evident by the towel over his shoulder. He was Arthur Wilfred Orton, and he lived in Cross Street. (*W. Orton*)

Four boats are seen abreast in this canal scene just south of the Bush or Tup Street Bridge, 1935. Tippers factory is just visible on the right of the picture. (*Dudley Archives*)

Ann Steventon stands on the canal towpath with a bouquet of flowers, facing Broken Bridge, as it was known (or more correctly Brierley Bridge). The bridge lay some 100 yards south of the Bush Bridge. In about 1950 a ghost was reported to have been seen on this bridge, attracting crowds of locals who hoped to see it. Soon after this photograph was taken in 1965 the canal was filled in. This section of the canal was known as the Wednesbury Oak Loop. (*M. Steventon*)

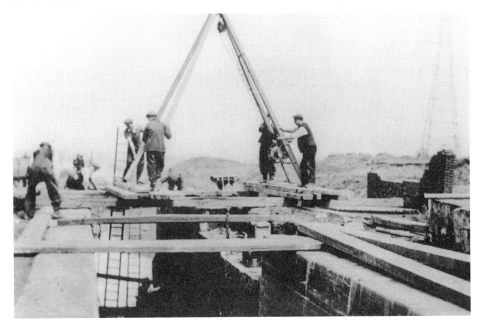

Workmen erecting a hoist over the Bradley canal second lock, 1933. Safety regulations and practices are not evident on this site, as nothing appears to be secured. The tripod-like hoists were called sheerlegs and lifting had to be straight, or otherwise the whole lot would collapse. (*Dudley Archives*)

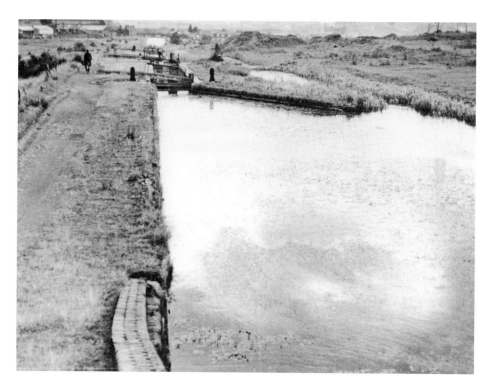

Looking down the Bradley locks. 1933. The man on the bicycle is riding towards Wednesbury. On the horizon from left to right is the high building of the Metro Cammel Carriage Works, then the two Wednesbury churches, the Willingsworth furnaces, immediately in front of the churches, and the chimney-stacks of the Patent Shaft Works on the right. (*Dudley Archives*)

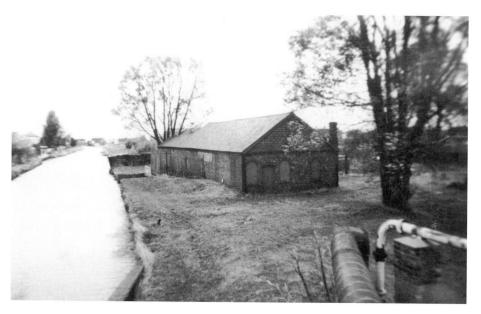

A pumping station alongside the Bradley canal at the British Waterways Workshop. (*Ron Davies*)

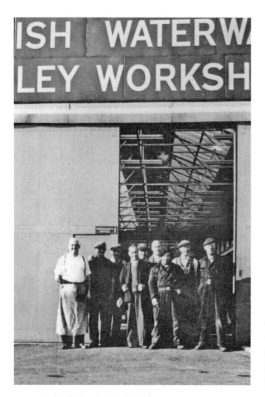

Outside the British Waterways Bradley
workshop, c. 1962. The gentleman in the white
shirt was nicknamed 'Poppa Dick'; others seen
here are Frank Williams, Harold Abbots and
George Wood. (*Wolverhampton Archives*)

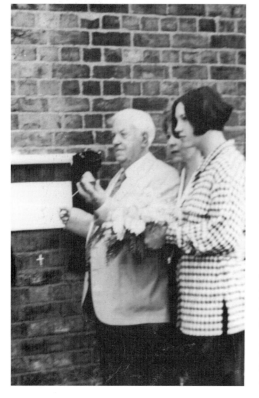

The unveiling of a memorial plaque to Maud
Fellows and William (Frederick) Fellows, who
were both killed by a Zeppelin bomb on this
spot, near the Bradley Pumping Engine, Monday
31 January 1916. Seen here are Wilfred Fellows
(son) with daughter Desnee and granddaughter
Sian. The unveiling took place in 1994.
(*William Edwards*)

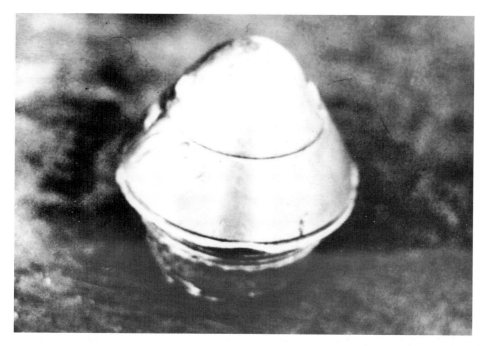

The cap from the bomb that killed Maud and William Fellows. (*Ron Davies*)

The houses seen in Daisy Bank were known as the Nine House Row. One of the houses, No. 45, was the home of Maud Fellows. The lodge seen at the end of the row led to Daisy Bank House, later Udall's Farm. (*Dudley Archives*)

John Smith enjoying the summer heat at the Rocket Pool in the days before the Rocket Pool estate. This was a vast area of pit waste mounds beloved by the local folk and wildlife alike. There were two pools then, separated by a causeway that also carried a stream. (*J. Smith*)

Bradley Lane, 1960s. Tom (Jotter) Perrins is on one of his noted walks; the occasion is the Bradley Marathon, which at one time was held every year. (*K. Cooper*)

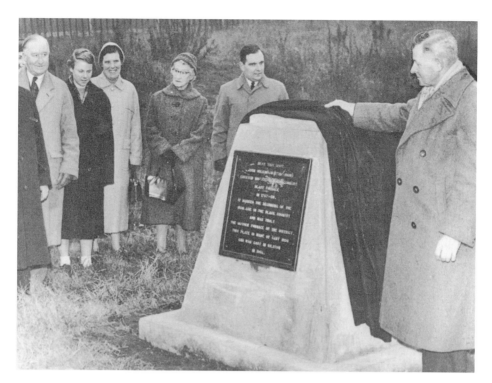

John Wilkinson founded the first Black Country blast furnace at Bradley in 1767-8. A memorial plaque was unveiled in his memory by Amos Hunt at the Great Bridge Road Playing fields on 24 November 1956. Wilkinson had other works at Broseley near Coalbrookdale. (*Wolverhampton Express & Star*)

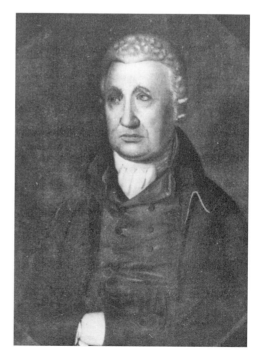

A portrait of John Wilkinson, the great iron master. (*John Price*)

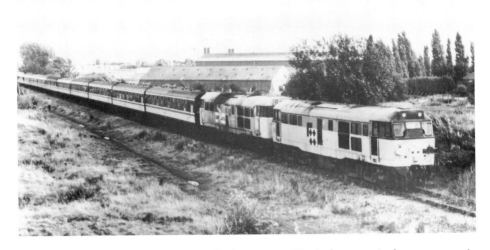

Although the GWR rail service from Wolverhampton to Birmingham saw its last passengers in the early 1970s, the line nevertheless still continued to freight goods on the odd occasion between Loxdale Street and Wednesbury. The passenger train seen here was a special and the last to be seen on this line; it was the idea of the Black Country Society to organise this before the tracks were finally lifted in preparation for the new Metro system, and it took place on 30 August 1992. The locomotive was supposed to have been a steam engine, and it was a great disappointment to all who gathered when this train stopped at what was the former Moxley-Bradley Halt (last used on 1 January 1917). The buildings in the background are the Thompson Bros Works. (*Ron Davies*)

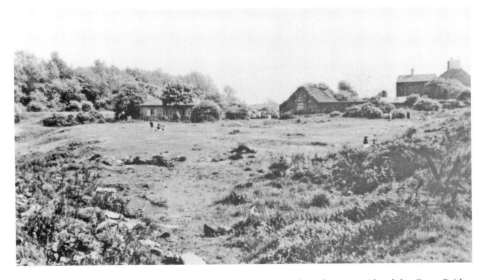

Moorcroft, 22 May 1959. This plot of derelict land is situated on the same side of the Great Bridge Road as the Fiery Holes public house close to Bull Lane, and was once heavily mined. During the nineteenth century the whole area was one of black smoking furnaces of intense heat. In about 1906 the smallpox isolation hospital for twenty-four patients was built on the site by Wednesbury Health Authority to the plans of Charles W. D. Joynson, who was also responsible for the Bradley Wesleyan church. It cost a total of £2,876. In 1906 the hospital was used for smallpox cases, and later for diphtheria. The buildings on the right are Moorcroft Farm. All these buildings were demolished in the 1960s to make way for a new housing estate. (*Wolverhampton Express & Star*)

three

Ladymoor

Along the railway line from Coseley Road station towards Capponfield. On the right of the picture are the last vestiges of the once huge slag heap. (*H. Eccleston*)

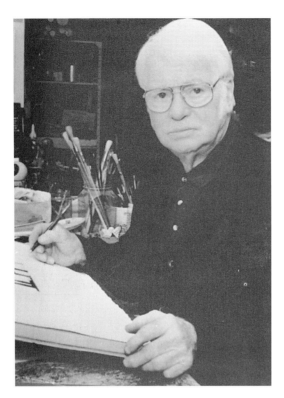

A portrait of Harry Eccleston in his studio, busy as ever. Harry Eccleston died on 29 April 2010. (*Edmond Sepple*)

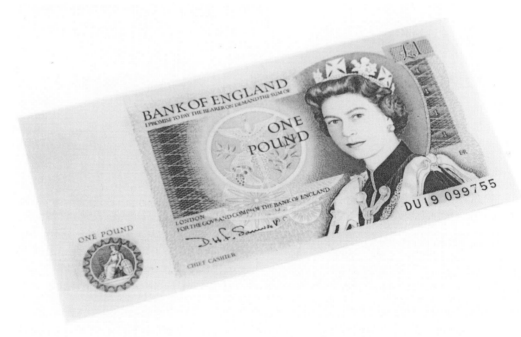

This is one of the banknotes that was so skilfully designed by Harry Eccleston OBE. The portrait of the Queen was never bettered. (*Bank of England*)

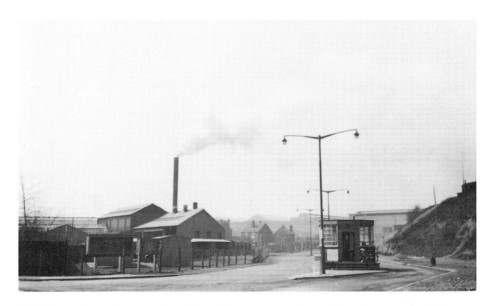

Until about the early 1960s the only traffic entrance to the steel works was a road that ran alongside the canal towpath from Millfields Road. A new road was later built in between E. N. Wright's and the Spring Vale Social Centre complex; this other new road was built where Coseley Road met Broadlanes. The railway embankment on the right of the picture carried rail goods into the works which are seen in the background. The buildings on the left belonged to Alexander Metals, while the house beyond that, in Moor Street, belonged to Dugmore's, the Ladymoor coal merchants. (*H. Eccleston*)

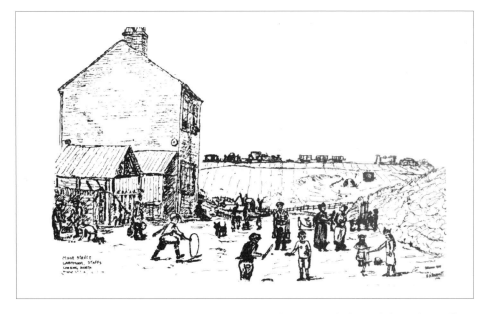

Moor Street, Broadlanes, drawn by Andrew Barnett in the 1930s. The house belonged to William Dugmore, who was the local coal merchant. The children are playing various popular games of the day – marbles, tip-cat, conkers, skipping – and one child has a bowling hoop. (*A. Barnett*)

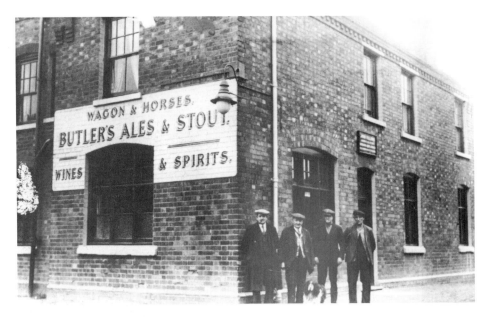

The Wagon and Horses public house in Moor Street, 1930s. This street went to the right and left of the picture. The pub was a very popular haunt, especially with the men who worked at the steel works who could get here at any time through the back entrance to the works. (*Ron Davies collection*)

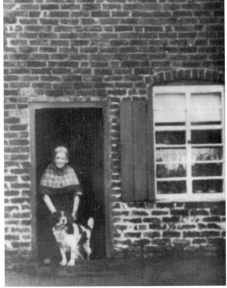

Above left: One of Mrs Geary's neighbours was Mr Hawkins. (*G. Hawkins*)

Above right: Mrs Geary stands in the doorway of her modest house in Broadlanes, *c.* 1935. It was one of a row of five or six dwellings adjoining the north side of the George and Dragon (the Clog) public house. (*G. Hawkins*)

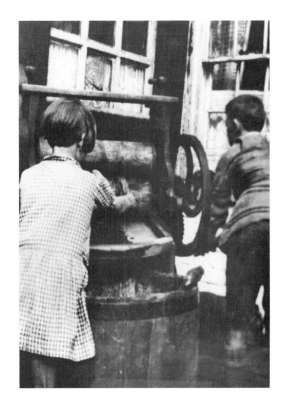

In the yard at the rear of Mrs Geary's, two children, Hilda Hallmark and Herbert Latham, happily play with the washing mangle. The handle of the maid can just be seen in the wooden maiding-tub. The maid was a heavy round lump of wood, fashioned with four short legs and attached to a handle, with which one pounded the washing. (*G. Hawkins*)

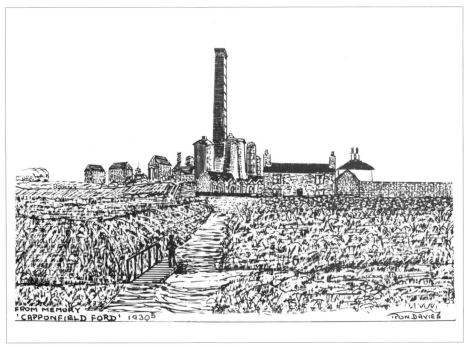

A sketch of the Capponfield furnace site from Broadlanes, *c.* 1935. In the foreground are the ford and the little footbridge. (*Ron Davies*)

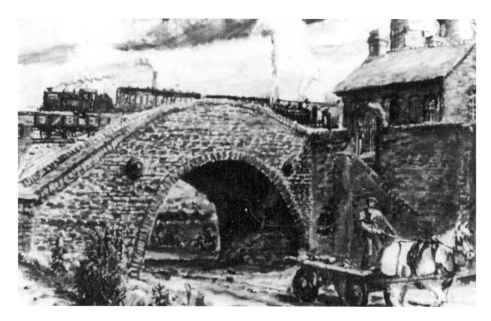

A painting by local historian, the late Andrew Barnett, *c.* 1929. It records vividly the setting of the Capponfield furnace. There were four bridges on this particular road from Bilston to Highfields. (*A. Barnett*)

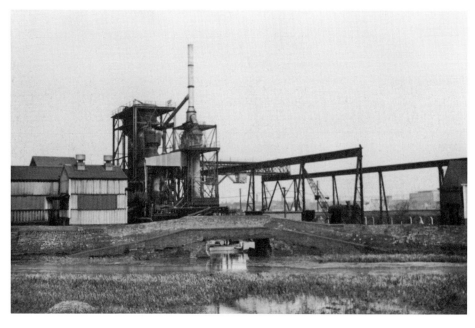

After many years of dereliction the Capponfield furnace site was brought back into use by its owners, Bradley & Foster's, this time with an up-to-date cupola furnace, again for the production of special metals. It was not a very popular industry with the residents in nearby Carder Crescent. This photograph was taken in about 1960. (*H. Eccleston*)

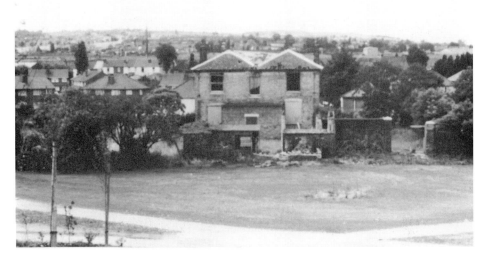

Capponfield House, *c.* 1980. It was built in 1842 by iron master John Bagnall for his works manager and was one of the very few remaining such properties; sadly it was allowed to fall into disrepair. (*Ron Davies*)

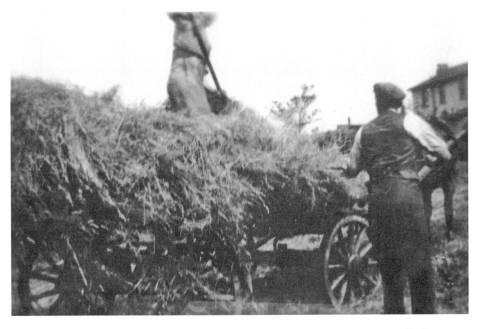

Haymaking in the shadow of Capponfield Works and Capponfield House, 1937. The farmer on the right is Bill Ramsbottom, who with only one leg made hay, tended and milked his dairy herd and, with his horse and float, delivered milk around the village. (*A. Barnett*)

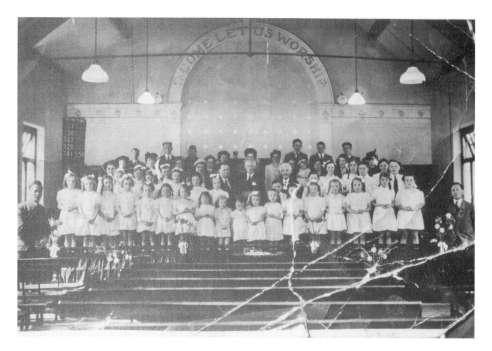

One of the mainstays of the village community was the little Methodist chapel, seen here in about 1937. On the extreme left is Arthur Jones; the girl nearest to him is Olwyn Dainty. On the far right is Andrew Barnett, and also included are Mr Barnett (the elder), the twin Bateman girls, Jean Dugmore and Harold Dugmore. (*A. Barnett*)

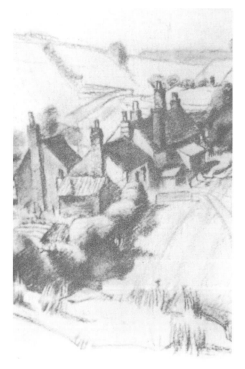

An old Ladymoor scene drawn in crayon by Robert Baker, *c*. 1925. It shows cottages that used to stand on the old road that led from Bilston to Coseley. This ran along the back of the present road but, because it was near to the steelworks tips, the whole soon became buried beneath the ever encroaching furnace rubbish. (*A. Barnett*)

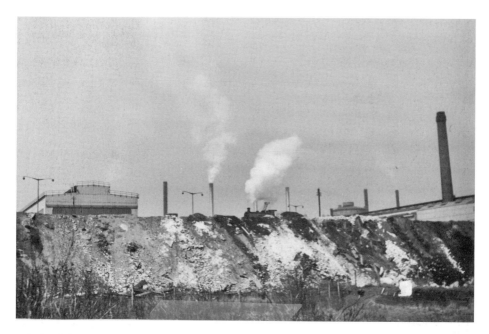

A little of the vast tipping site used by the steel works. The building on the top dealt with all the scrap intended for the various furnaces. By about 1965 the Ladymoor tip could take no more, and the vast open area on the other side of the Stour Valley Line and the canal was used for that purpose. Sedgemoor housing estate now occupies the site. (*H. Eccleston*)

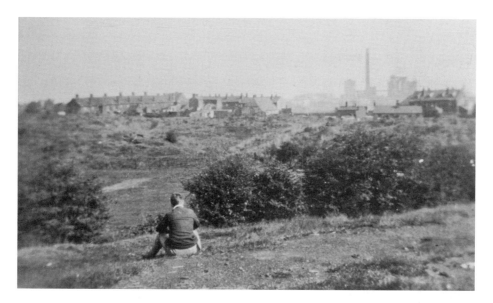

Broadlanes from the Ladymoor Pit Banks. In the background is the Capponfield Iron Works, while the building on the right is Broadlanes School. Immediately in front of the Capponfield Works is Tom France's cottage, and to its left is St Oswald's Mission Hall. The buildings on the left are Prestons Row, and in the middle foreground is Mr Hill's field. He was the local undertaker, and this is where he grazed his team of black horses. (*A. Barnett*)

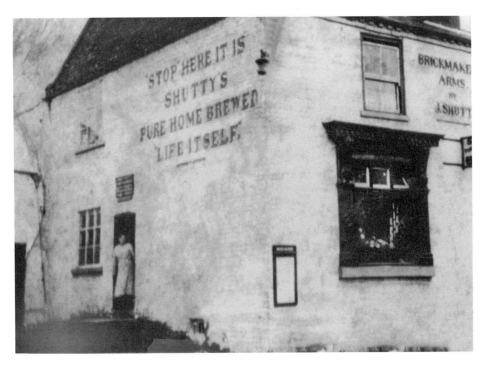

The Brickmakers Arms in Broadlanes, better known as Shutty's. It was Jim Shutt who brewed his own beer here in the 1930s and '40s. In the doorway is Elizabeth Shutt. (*E. Lavender*)

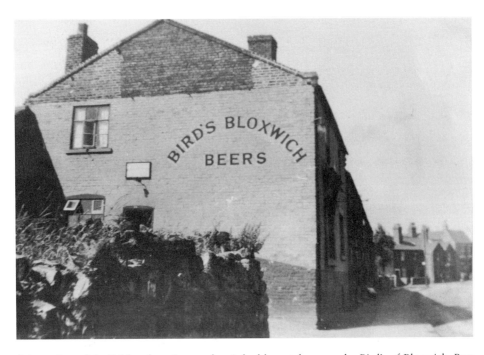

A later view of the Brickmakers Arms, when it had been taken over by Bird's of Bloxwich. Part of the old village is in the distance. (*Ron Davies*)

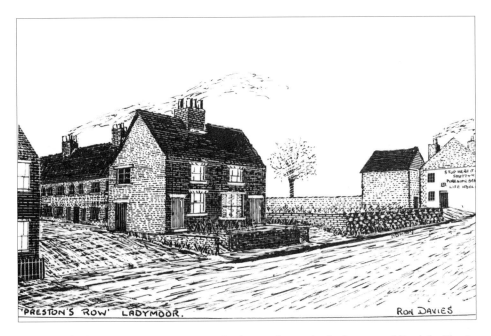

A sketch of what was once Preston's Row. In the two houses in the foreground lived the Blewitt family and the Bowens. On the right is the Brickmakers Arms. (*Ron Davies*)

By the mid-1970s there was very little left of the old village, and the little St Oswald's Mission had become redundant and was left to the vandals. It was built in 1888 mainly from cinder donated by Sir Alfred Hickman. Though simple, it was architecturally a very rare building, and really should never have been lost to us. (*Ron Davies*)

Mr Bonehill's cottage was opposite Broadlanes School. Before the Wesleyan church was built in 1849 the cottage was used for services. (*A. Barnett*)

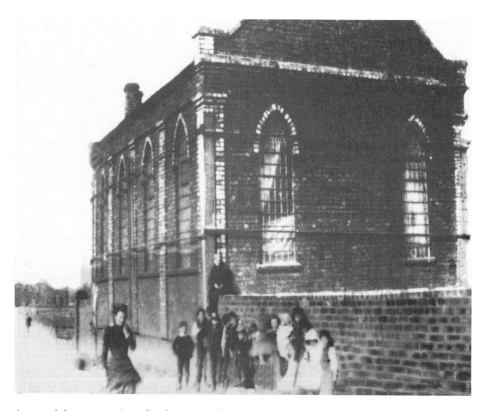

A turn-of-the-century view of Ladymoor Wesleyan chapel of 1849. It stood on the site of the present school buildings. The lady in the photograph is Mrs Phoebe Carron, who belonged to a well-known family in the village. The church was demolished in 1903 owing to subsidence. (*A. Barnett*)

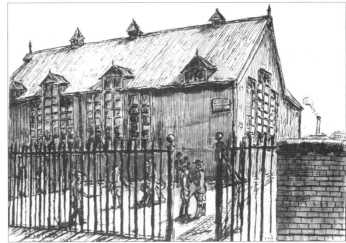

Andrew Barnett's sketch of Ladymoor Tin Schools, *c.* 1921. Being a schoolteacher, he loved to include children playing in his drawings. The smoking chimney-stack of the Capponfield Works is just visible in the background. (*A. Barnett*)

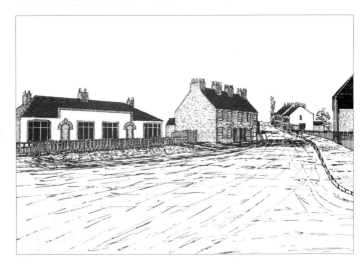

Ladymoor from Highfields Road, *c.* 1955. Part of Ladymoor Schools is on the right. The bungalows on the left were built in 1934 and demolished in about 1975. The older houses further along were a mixture of double and back and front; the terrace houses in the distance still exist. (*Ron Davies*)

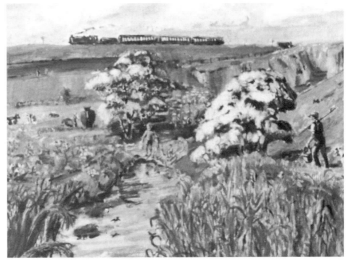

A delightful Ladymoor spring scene by Andrew Barnett showing an area known as The Bubble, *c.* 1930. The stream, now ducted, was the origin of the Bilston Brook, and further on the River Tame. The railway on the horizon is the Stour Valley Line, which was part of the LMS. (*A. Barnett*)

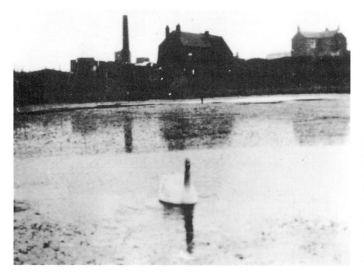

Looking across the pool at Ladymoor, *c.* 1935. In the distance is the chimney-stack at Capponfield Iron Works. The house in the centre was quite a crooked affair, having been affected by the many pit workings in the area. (*A. Barnett*)

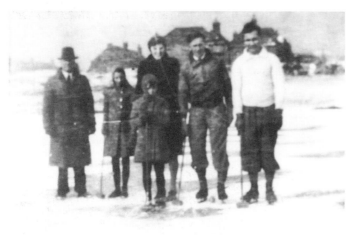

Winter time on Ladymoor Pool, 1930s. Left to right: -?-, -?-, Jean Dugmore, Andrew Barnett, Arthur Jones. The name of the child at the front is not known. Broadlanes School is in the background. (*A. Barnett*)

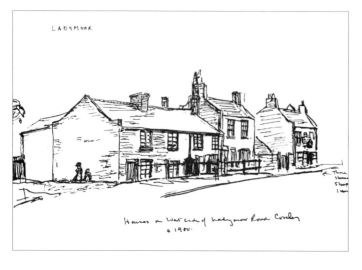

Old houses in Ladymoor, *c.* 1914. A bungalow now stands on the site of the sunken houses on the left. The driveway at the side once led to a slag-processing plant known as the Cracker; it also formed part of the old road from Bilston to Coseley. The end building was the former Three Horse Shoes public house. (*A. Barnett*)

A painting of Blue Button Colliery by Andrew Barnett,
c. 1920. The chimney-stack at the Blacking Mill, Deepfields,
is visible on the left. The train on the Stour Valley Line and
Hickman's works are in the distance. The conical hill was
spoil from the pit, and known as Blue Button Bank.
(A. Barnett)

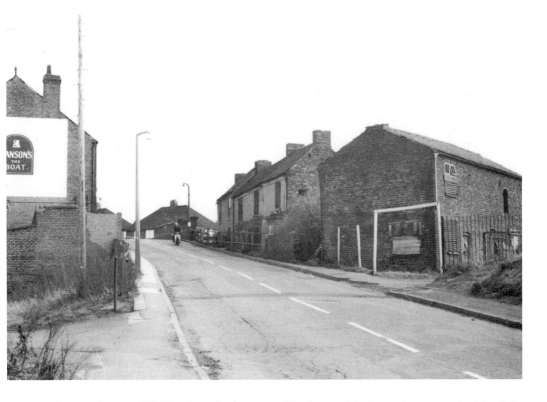

Looking up from Highfield or Boat Bridge, 1970. The Boat public house is seen on the left of the
photograph; the first building on the right was a stable for the boatmen's horses when they tied up for
the night, and the next building up was the former Bee-hive Inn. The other buildings were houses. The
land here contained, in the past, a refinery or cupola furnace, belonging to the Chillington Iron Works
at Capponfield (according to a deed of that land dated 6 May 1904). (Ron Davies)

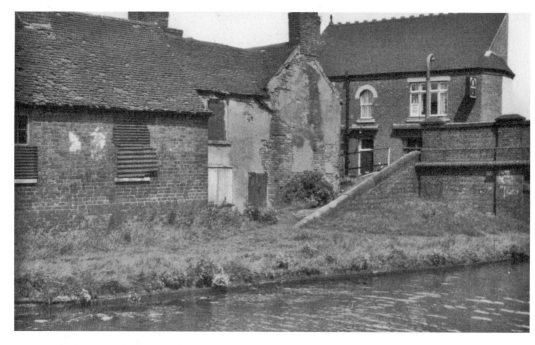

Highfield Bridge, the Boat pub and canalside houses, 1970. (*Ron Davies collection*)

Acknowledgements

Ron Arnold, the late Robert Baker, the late Andrew Barnett, Mrs Angela Bird, C. and J. Boden, Jack Braddock, Norma Bradley, Josie Brown, Nancy Cole, Gwen Cooper, Ken Cooper, Dorothy Davies, Harry N. Eccleston OBE, Sheila Edwards, William Edwards, Charles Evans, Rita Evans, Rene Faulkner, Ray Fellows, Marjorie Francis, Trevor Genge, Arthur Gough, Vi Grainger, Anne Griffiths, Michael Hale, G. Hanrahan, George Hawkins, Connie Higgs, T. J. King collection, Bett Lavender, Lloyds TSB (Bilston), the late Arthur Lyons, Alan Mason, Jennifer Martin, Doug Meese (in Australia), Ron Moss, Wilf Orton, Arthur Rea, Frank Rudge, Jim Salt, Harry Sheperd, Bill Shorthouse, the late Jack Smith, John Smith, Mr and Mrs Pat Squire and Roy Squire, Maud Tilley, Messrs Walker & Wootton Photographers, Ann and Kath Whitehouse, Edna Wilson, Arthur Wootton, Ron Wright, Sam Wright, staff of Wolverhampton Archives, Bank of England, staff of Bilston Library, Birmingham University School of Continuing Studies, John Price and Sons Printers, Bilston, *Wolverhampton Express and Star*. Further acknowledgements are due to the Black Country Society, the T. J. King collection and others with kind permission of the Dudley Archives. The authors are most grateful to everyone who has loaned or donated photographs, either in the past or specifically for this book, with special thanks to all the anonymous donors.

Every effort has been made to contact all copyright holders of photographs where copyright has not originated with the person owning them.